To Ernie + Bob
enjoy old C-on-H
Love
Peg + Henry

M000198729

IMAGES
of America

CORNWALL-ON-HUDSON

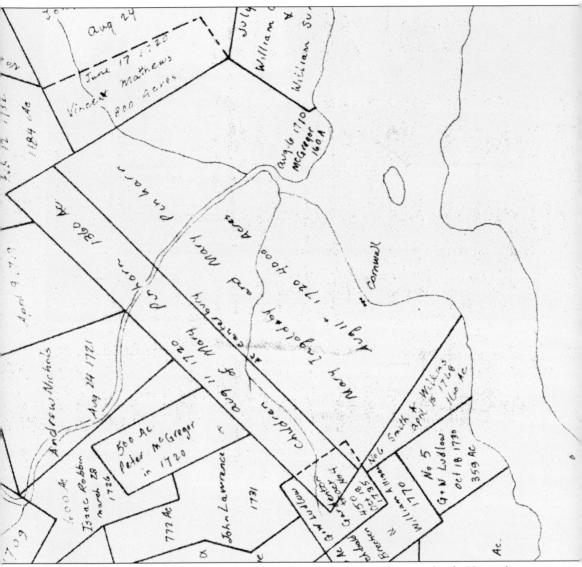

The Evans Patent map shows a portion of the original Patrick MacGregorie lands. His settlement and trading post were the first in Orange County in 1685. After MacGregorie's death his descendants Mary Ingoldsby and Mary Pinhorn had to petition for the land, because it had not been properly recorded. Their inheritance included what is present-day Cornwall.

On the cover: Please see page 119. (Bettyjane Costabel collection.)

IMAGES
of America

CORNWALL-ON-HUDSON

Colette C. Fulton

ARCADIA
PUBLISHING

Published by Arcadia Publishing
Charleston SC, Chicago IL, Portsmouth NH, San Francisco CA

Printed in the United States of America

Library of Congress Catalog Card Number: 2008930179

For all general information contact Arcadia Publishing at:
Telephone 843-853-2070
Fax 843-853-0044
E-mail sales@arcadiapublishing.com
For customer service and orders:
Toll-Free 1-888-313-2665

Visit us on the Internet at www.arcadiapublishing.com

This book is dedicated to my husband, Bill, a faithful and cheerful companion for more than 50 years, and to Bettyjane and Henry Costabel, whose marriage preceded ours by one month. Their interest in history and all things old and unique has helped to preserve a special era in Cornwall-on-Hudson, our hometown.

Contents

Acknowledgments 6

Introduction 7

1. A Mysterious Arrival 9

2. Animals Pose 17

3. People at Work 27

4. People at Play 39

5. How Did They Get There? 57

6. Familiar Faces and Places 67

7. Fashions of the Day 83

8. For Love of Country 111

9. On the Hudson River 121

ACKNOWLEDGMENTS

This book would have never come to be without a generous grant from Sen. William Larkin that allowed the Village of Cornwall-on-Hudson to purchase the necessary equipment to scan the glass plates and to catalog the history. Police chief Charles Williams selected and put together all the purchased items and gave some instruction in its use. I will be forever indebted to Joseph DeLorenzo for continued education in the use of the computer, the many hours he gave assisting in the project, and his remarkable ability to smile through it all. Many thanks are due my husband, Bill, my right-hand man for jobs too numerous to mention but mostly for his loving support. The encouragement of Kathleen, Karin, and Ryan was a blessing. Lastly but most importantly, thanks are due Bettyjane Costabel, who purchased the glass plates and sorted through them carefully with gloves, and her husband Henry Costabel, who carried crates of them hither and yon, and their willingness to share them for the benefit of recording a particular era of Cornwall-on-Hudson history. You are special people. I would also like to acknowledge Doris and Jane Hennessey, grandnieces of Alice and Louis Chivacheff; Janet Dempsey, town historian and treasured friend; Cornwall Public Library Index; Allyne Lange; Russell Lange; Patricia Favata; the Historical Society of Newburgh Bay and the Highlands; Elizabeth McKeon, City of Newburgh Records Management; Dorothy Orr Calamari; John Caudy; Henry Costabel Jr.; Karin F. Caufaglione; and Loretta K. Fanning.

INTRODUCTION

Cornwall Bay provided a beautiful view for Henry Hudson as the *Half Moon* sailed up the river that would eventually bear his name. Robert Juet recorded in the ship's log that "this is a pleasant place to build a towne on." By 1685, Col. Patrick MacGregorie, his brother-in-law David Toshuck, and a party including William Sutherland settled along the mouth of the Moodna Creek. He built a log cabin and conducted a trading post with the native people and became proficient in their language. He was called off to battle and lost his life, and his dependents were left to petition for their rights to the land, which had not been properly recorded. That early settlement was the first in all of Orange County, the area called Cornwall, embracing parts of many present-day towns. Sarah Wells and a party representing Christopher Denn, her adoptive father, would have passed the remnants of the early settlement and trading post on their way up the waterway to establish claim on Denn's land in present-day Hamptonburg.

Families by the name of Clark purchased acreage from Mary Ingoldsby in 1748 in what is now Cornwall-on-Hudson. Some of their descendants live in town. Jeremiah Clark was a member of the committee of safety, a delegate to the Continental Congress, and a friend whom George Washington visited. The waterfront provided the landing for sloops and later steamboats that transported goods and people from one place to another. Robert Fulton's steamboat the *North River* (called by some the *Clermont*) passed here on its maiden voyage in 1807. Nathaniel Parker Willis arrived in the 1850s for health purposes and employed Calvert Vaux to construct a cottage villa for him. From here he wrote many articles for the *Home Journal* about Cornwall. He renamed Murderer's Creek, the Moodna and Buttel or Butter Hill, the Storm King Mountain. Lewis Beach, a local congressman, wrote the first book about Cornwall in 1873 and stated that "the three things which conspire to give Cornwall the prominence it enjoys, are 1st The salubrity of the air; 2d The beauty of the scenery; 3d Its accessibility to the city." He goes on to mention that there are eight first-class river steamers stopping at Cornwall, including the famous *Mary Powell*, as well as train connections to and from New York City.

There was an agitation to incorporate the part of Cornwall closest to the river (including some mountain property) 10 years later. In December 1884, a favorable vote was reached, and Thomas Taft was elected the first president of the Village of Cornwall (called Cornwall-on-Hudson). He was a man much interested in the progress of the community, promoted a power plant for electricity, and improved telephone service and other important needs. An architecturally lovely bandstand was built by Mead and Taft, and all enjoyed evening concerts all summer. The Storm King Engine Company was an active group of firemen with a firehouse on Duncan Avenue and a new one proposed on Hudson Street. Library Hall and Opera Hall Rink provided rooms for

dancing, fairs, graduations, lectures, plays, and roller-skating. Numerous grocers, pharmacists, and shops and various boardinghouses and hotels gave visitors the opportunity to experience the healthful air, scenery, and social activities.

Louis Chivacheff, an immigrant from Bulgaria, arrived in Cornwall in the midst of a growing and busy community in 1890. He boarded on a local farm, attended school to learn the English language first and others schools of learning later, and became interested in photography. Bettyjane Costabel found the remnants of this lifelong hobby in the basement of the home he built. No one knew at the time what a very exclusive history of Cornwall-on-Hudson it was. There are only a few images of other places. This book is about the era of his arrival and what he chose to capture in the community where he married and spent the rest of his life.

One

A MYSTERIOUS ARRIVAL

Louis Chivacheff was born in Bulgaria in 1869, the son of Hirsto and Kariaka A. Chivacheff. He came to America soon after his graduation from a military school in his country. Louis was energetic and thirsty for education. Claverack College and Hudson River Institute was his choice for learning the English language. Both Stephen Crane and Martin Van Buren were students there. He studied engineering at Ohio-Northwestern and then settled on a farm in Cornwall. What brought him here was a mystery, and he himself was a mystery to many of Cornwall's citizens.

The art of photography fascinated Louis, and he learned the techniques from a Newburgh photographer. Was that man named Richard Atkinson, someone who lived in Newburgh but had a studio in Cornwall-on-Hudson? The photograph shop that Louis bought was not a new one.

Louis's next area of interest was teaching, and in 1911, he was hired as the industrial arts instructor and art supervisor at the Cornwall-on-Hudson High School on Idlewild Avenue, a position he held until retirement almost 20 years later. When school was closed in July and August, Louis continued his thirst for education and took courses at Adelphi over several summers in Greek, Roman, and Medieval education, child study, psychology, and ceramics. The pottery courses brought about another aspect of his artistic ability and later led to his appointment as a lecturer on ceramics at an Art, Drawing, and Manual Training Conference in Newburgh and his election as president of the Drawing and Industrial Arts Teachers of the Hudson Valley.

Louis fell in love with a local girl named Alice Morris. Louis and Alice were married in St. John's Episcopal Church on Christmas Eve of 1916. Following the ceremony, the bridal party drove to their own delightful new home on Hudson Street, where a wedding supper was served. The interior of the cottage had been decorated by the bride's nieces with flowers and lighted candles and presented a beautiful appearance. The newly married couple enjoyed their honeymoon quietly at home, the groom having a week's vacation at this time.

Louis Chivacheff was a man who thirsted for education, became obsessed with the art of photography, and took more than 3,000 images of people and places in the town he adopted and where he spent the rest of his life. He established his business under the name of Storm King Studio, and there, within the view of the beautiful mountain itself, he taught school and continued his productive hobby.

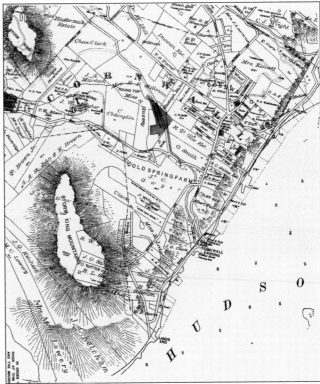

The 1891 map shows the incorporated village of Cornwall (called Cornwall-on-Hudson), Storm King Mountain, and docks and businesses along the Hudson River shoreline.

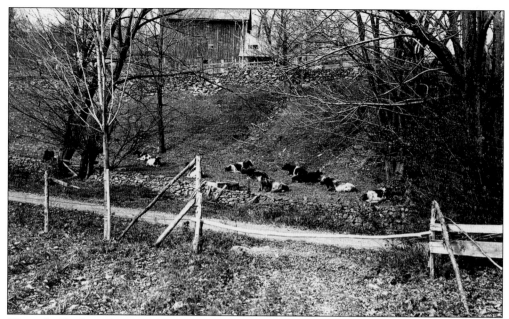

Chivacheff's first photographs were taken outdoors with natural lighting. He captures the serenity of resting and grazing cows enclosed in stone and wood fencing on one of the many farms in Cornwall.

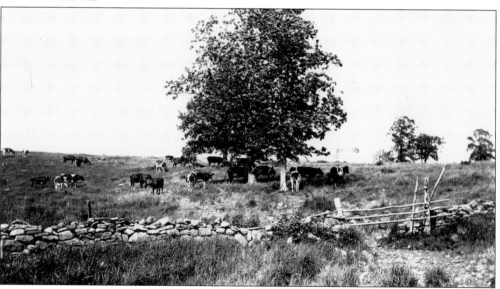

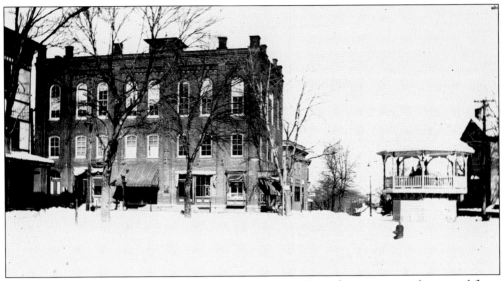

Library Hall was built as a subscription library in 1870 with reading rooms on the second floor. A large auditorium with a stage occupied the top floor. The rentals from businesses on the street level helped to maintain the building. It was a busy center in the village.

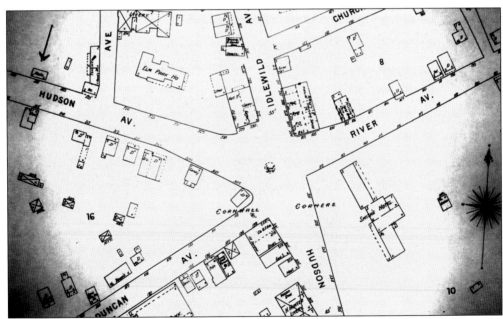

The Sanborn map shows the village square, the bandstand in the center, Library Hall on the corner of Idlewild Avenue and River Avenue, Opera Hall Rink on Duncan Avenue, and the photograph shop marked with an arrow. An earlier photographer named Richard Atkinson lived in Newburgh but had a shop in Cornwall. He may have been Louis Chivacheff's teacher, and this may have been his shop that Chivacheff purchased. The 1908 tax list shows that he paid $1.87 on a shop worth $150. He was now clearly set up in business on Hudson Street.

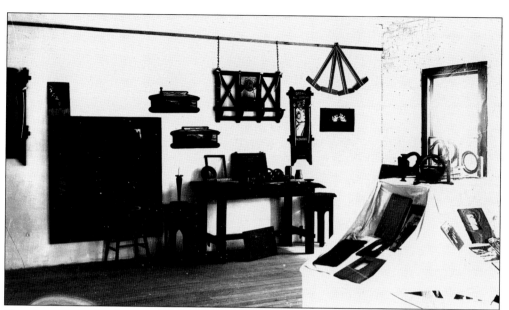

Here is an example of some of the articles made in industrial arts classes. Chivacheff's degree in engineering from Ohio-Northwestern was put to good use in his teaching career, which began in 1911.

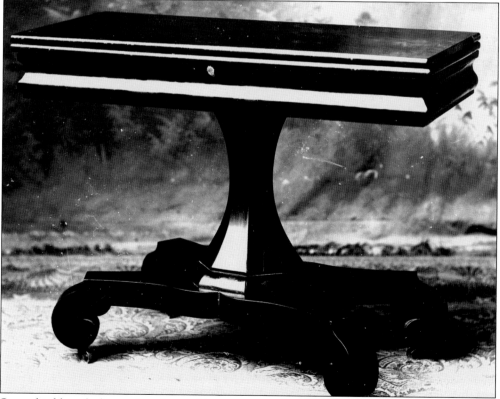

Several tables of advanced workmanship are among the glass plates. This lovely wooden table was probably one of his creations in anticipation of building and furnishing a home someday.

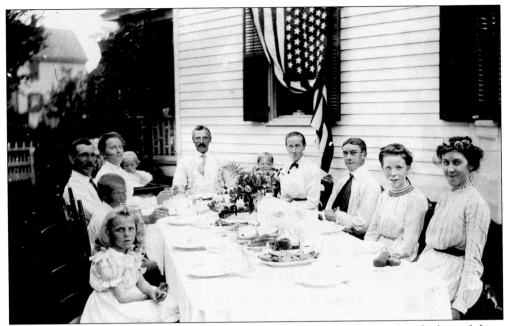

Here is a holiday picnic at 30 Avenue A. There are no plastic utensils here but the best of china and glassware, a flower arrangement, and platters of food. Alice Morris sits demurely on the right, and the empty place at the table awaits the photographer.

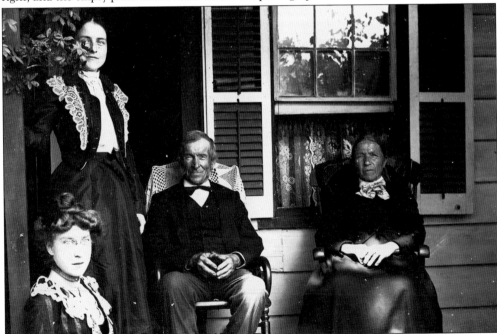

Alice is seated on the left with family members. She was one of four daughters of William and Sarah Jones Morris. Charlotte married Augustus Frederickson, Mabel married Daniel Little, and Alice married Louis Chivacheff, and they all lived in town. Another sister married and lived in England. Hazel, a daughter of Augustus Frederickson, married Augustine T. Hennessey, and their daughters Doris and Jane reside in the charming 1890s house today.

St. John's Episcopal Church was constructed in 1859. This is a rear view of the church where Louis and Alice were married on Christmas Eve of 1916. Mabel and Dan Little were the attendants. It was their church through their married life, and when Louis's mother, Kariaka, died in 1925, he fashioned a crucifix that he presented to the church in her memory.

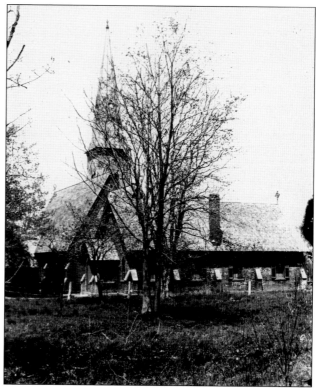

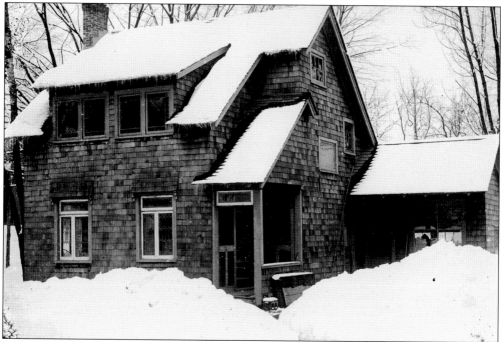

This is the house that Louis built with assistance from some of his students. When Bettyjane Costabel purchased the glass plates, some of the windows and colored glass panels were found in the basement of the house.

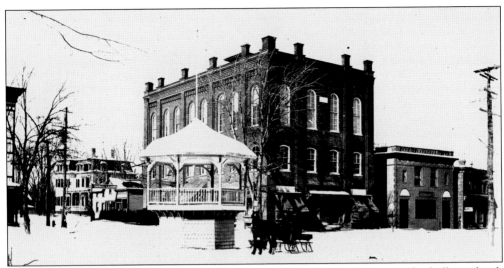

Here is a view of Library Hall and the Mead and Taft bandstand. Next to the hall is a bank constructed in 1897. Erard A. Matthiessen, who was responsible for having both structures built and was one of the bank's first depositors, suffered a loss when a cashier absconded with the funds in 1906. In his philanthropic manner, Matthiessen gave the bank to the village for use as corporate offices. It remained the village office until 1991, when another larger bank became available.

Bells announcing the approaching horse-drawn Buffalo Speeding Cutter must have been a cheerful sound, one not heard by generations of today.

Two

ANIMALS POSE

Louis Chivacheff used the natural light of the outdoors when posing his early images. There are several pictures that show the reflection of him and his covered box camera. Residing on a farm offered abundant animals and peaceful scenery. Cows, chickens, horses, and dogs were all available, yet to keep a rooster still long enough for a decent photograph must have been a challenge. He progressed to include people with more than one dog and groups on horseback. Once he established a studio for himself, he posed dogs and their owners. His lighting then came from a ceiling window to one side of the subject, which explains the clear side and the shadow side of the face.

The Cornwall Poultry Association held a yearly competition for those who raised unusual breeds. Ribbons were awarded for the first, second, and third prize, and the Village History Museum has a number of them in the archives. They were gifts from Benjamin King, whose father, Howard King, was a member of one of the Poultry Breeding Organizations. Poultry breeders entered their specimens in New York City and St. Louis, where one Cornwall exhibitor received a silver cup in 1904.

Horses were not mere pets but hard workers who carried men and women from one place to another or in pairs pulled work wagons and buggies. Before automobiles were affordable, horses were a necessity to everyone. One elderly family member remarked that the only time he saw his father cry was when his favorite horse died.

Louis enjoyed posing children and their pets. He and his wife, Alice, had no children of their own and Alice, as a surprise, invited children to his 50th birthday party in October 1919.

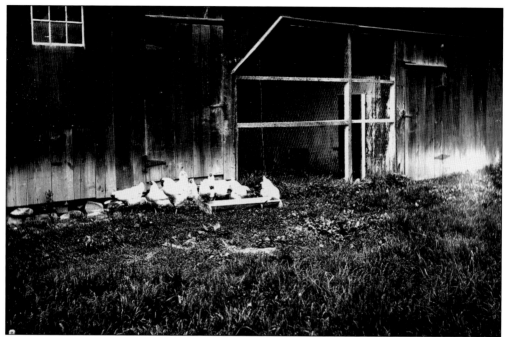

Here is another farm scene, this one of chickens near the barn. The barn bears a striking resemblance to one on the Houghton Farm, an experimental farm where the brother of Homer Winslow was employed. Homer spent several summers there and painted some of his pastoral period paintings at that time.

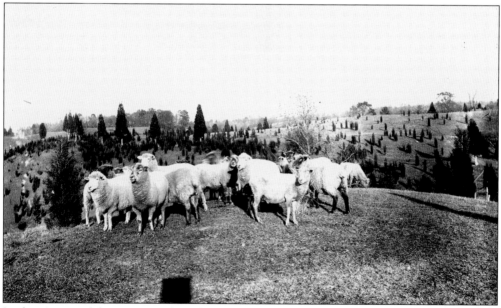

In this picture of sheep, notice the reflection of the box camera and tripod. It was likely taken on Round Top Hill, the property of Sarah J. A. Hussey, an editor and writer for an early Cornwall newspaper.

The Cornwall Poultry Association was an organization formed by men who liked to breed and show fancy chickens. Many of them were shown in shows in New York City and St. Louis and were prizewinners. These photographs were taken indoors and must have presented a particular challenge.

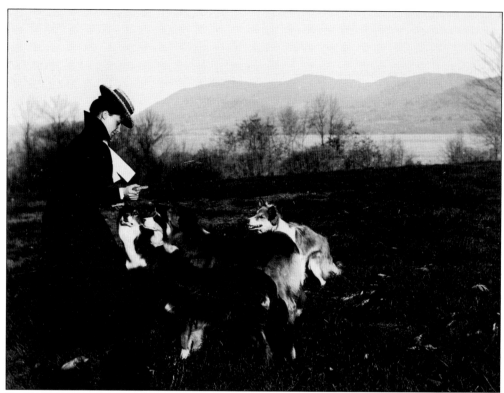

Residents of some of the Storm King Mountain estates had ample room to raise dogs and horses. The dogs are gathered around their mistress as she offers a treat, and then a horse is added to the menagerie. Outdoor scenes such as this one give an idea of the elevation of Cornwall-on-Hudson from river to mountain.

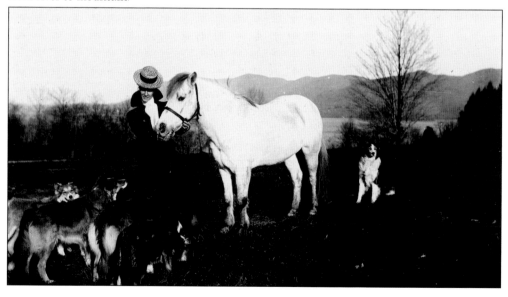

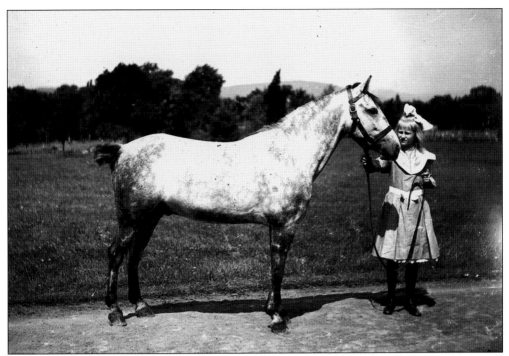

Youngsters growing up at the dawn of the 19th century learned to care for the horses that were a necessary part of everyday life. The young girl here shows off a dapple gray and wears the typical dress of the period. Blue jeans were a long way into the future.

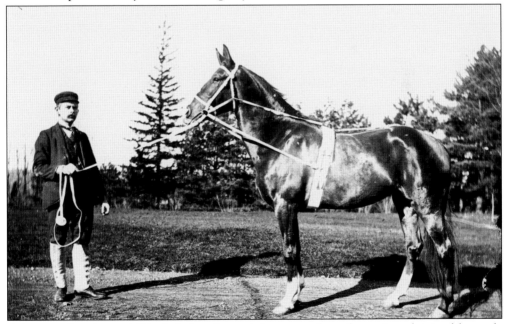

A horse and trainer exhibit their best form. A horse may be a domesticated animal but only reaches the level of obedient and trusted worker through the efforts of the person training the horse. Certain men were known for their extraordinary ability to handle an animal, as shown here.

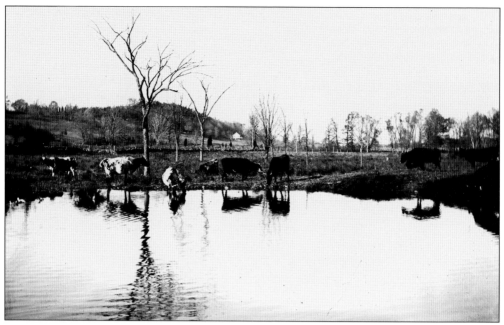

Drawn often to the pastoral scenes of Cornwall's farms, Louis Chivacheff captures here the reflection of grazing cows by the water. Setting up his equipment outdoors was his usual method before acquiring the photograph studio.

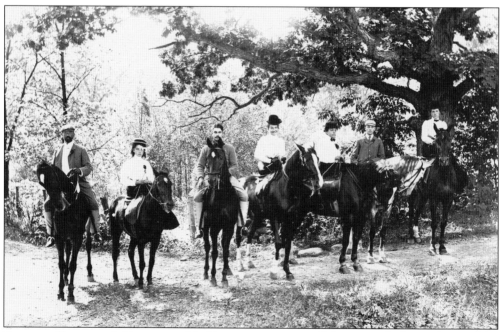

A group of horses and riders means 14 objects must remain still for a period of time. Some of the boardinghouses offered the opportunity to plan a ride on the numerous trails about Cornwall. Notice the ladies riding sidesaddle.

Tax ledgers list dog owners along with property information. Most Cornwall residents were owners of dogs and some were interesting breeds. The St. Bernard shown in this photograph was almost as big as his mistress, who had her hair curled for the photograph session.

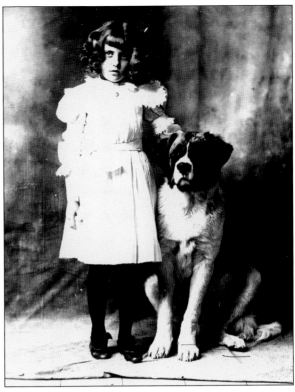

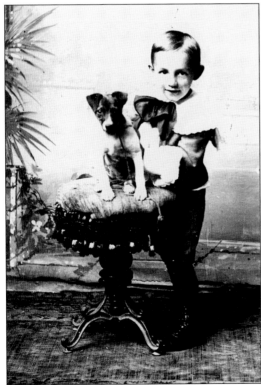

Chivacheff made use of an antique piano stool to pose a puppy with his delighted master. Children held a special fancy for him, but unfortunately, he and Alice were childless. She invited only children to his 50th birthday party, as reported in the local newspaper.

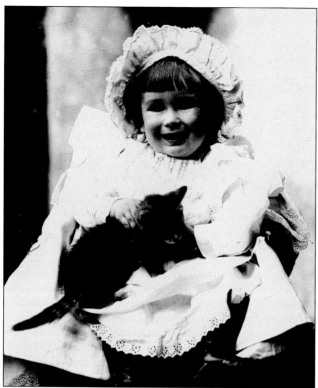

Surprisingly, while it is hard to tell if this baby is laughing or crying as she holds her kitten, she remained still long enough to be photographed without a blur. The eyelet-trimmed dress and bonnet are typical of the period.

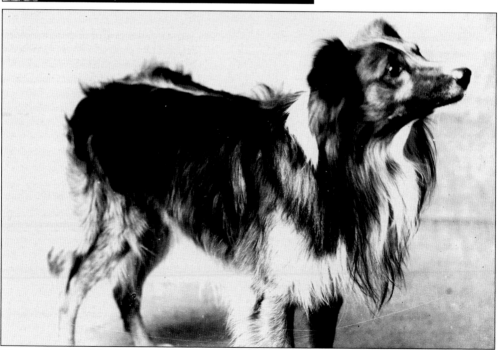

The tender face of this long-haired collie would be perfect for a calendar. Some business calendars of the early 1900s often featured a large animal on the upper half with tear off calendar pages below that measured only two by four inches.

It was a novelty for some to have a wild animal for a pet. The chained raccoon climbs on a wooden towel rack.

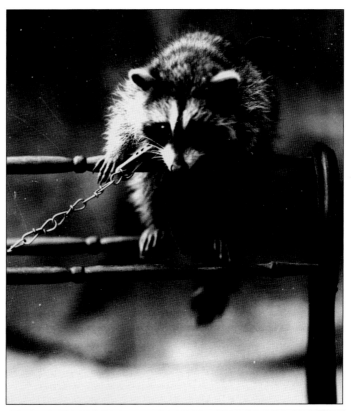

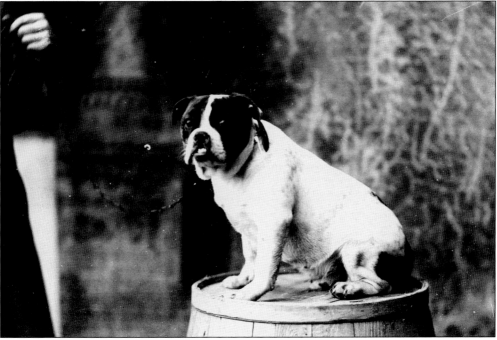

A cute pug posed on a barrel with the master's hand quite near shows another of the many dog breeds in favor long before there were dog ordinances and leash laws.

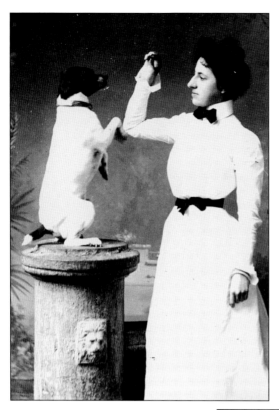

A well-trained pet begs for a treat on one of Louis Chivacheff's props and then relaxes with his owner. Fox terriers were another popular breed of dog and can be seen in the background or being held by owners in a number of the glass negatives.

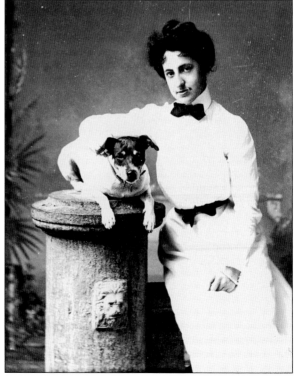

Three

PEOPLE AT WORK

Cornwall had three major employers, the Firth Carpet Company, the Mead and Taft Company, and the Ontario and Western Railroad Company Coal Dock. The Firth Carpet Company was the outcome of the purchase of a former mill by two gentlemen from England by the name of Firth. Weavers from England and Scotland came to America to work in specific departments and of course remained residents. The company employed numerous local citizens and was Cornwall's equivalent to International Business Machines in that a family atmosphere was encouraged with annual family picnics, a clubhouse with a bowling alley, mill houses for rent, and eventually a weekly publication. The many Scotch descendants who reside here formed a bagpipe band called the MacCleod's, which enjoys a notable reputation today.

The Mead and Taft Company, a building enterprise established in 1843, was a large employer for almost 100 years. Started by Charles Mead, with Daniel Taft soon joining him, the business was in need of larger quarters when Daniel's son, Thomas, returned from the Civil War duties and a plant was constructed at Cornwall Landing. The firm built many homes in town and quality homes in Tuxedo Park, Newport, Long Branch, and other places once its reputation became well known.

Thomas Taft, the first president of the Village of Cornwall, was responsible for bringing the Ontario and Western Coal Dock to Cornwall Landing. A January 1890 newspaper article stated, "It is hoped and is certainly most devoutly prayed for that the extension of the Ontario and Western Railroad to the Scranton coal fields will lower the cost of coal at least two dollars a ton up this way. . . . The extension of this line would create the necessity of extensive coal docks at Cornwall Landing." The docks were completed in 1892, the stationary engines that would hoist the cars on the trestle arrived in August, and by November as many as 95 cars were being unloaded in a single day.

The Barton and Spooner Woodworking Company was a lesser employer, although a well-known business that made souvenirs of wood from Storm King Mountain. The Elmer House became a cancer sanitarium in 1905 and employed several local nurses.

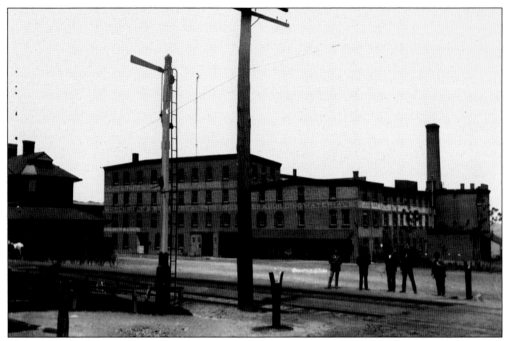

The Mead and Taft Lumber Company was well known and well respected. Its dock was at the rear of the building on the Hudson River. Many of the village homes were of its construction, and later it expanded to build houses all over the country. Note the Cornwall-on-Hudson railroad station to the left of the photograph.

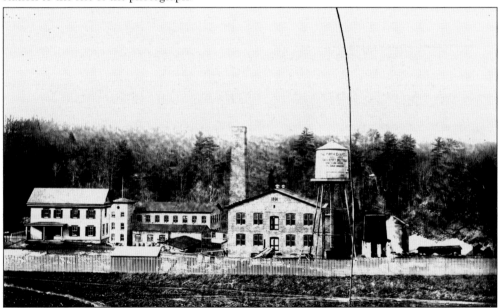

The Firth Carpet Company was a family-oriented business. Homes built on Firth Street and Algernon Street in the town afforded reasonable rents for the employees. In 1909, the company wove a small rug commemorating the Hudson-Fulton Celebration. Family picnics were an annual event, a clubhouse was erected to accommodate a number of activities, and later a newsletter was printed, keeping employees aware of happenings among them.

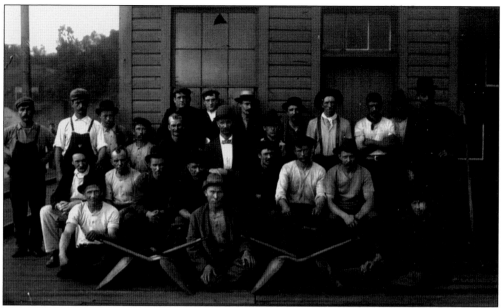

When the railroads were being constructed, a number of foreigners came to town to lay the ties. The tools of the trade were picks and shovels. Here Louis Chivacheff sets up an artistic pose.

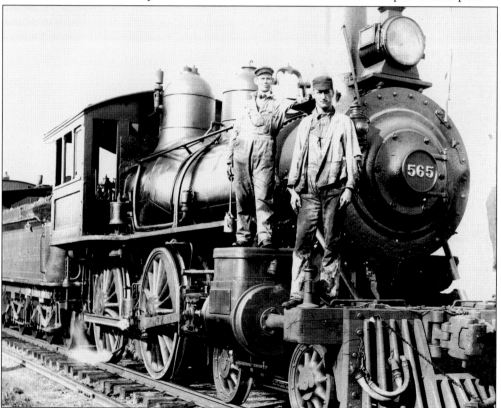

Workers on the railroad who maintained the steam engines were very proud of their responsibilities. Notice the long-nose oilcan in the hand of one of the workers.

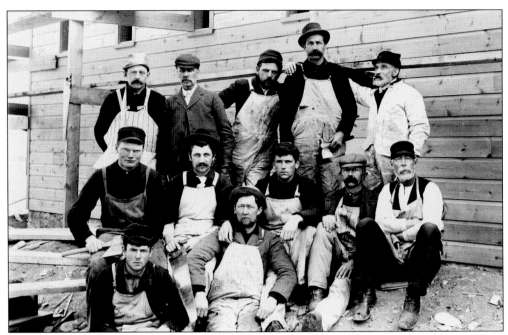

Carpenters relax with some of their tools, a couple of hatchets, and a saw, and all outfitted are in pocketed overalls or aprons.

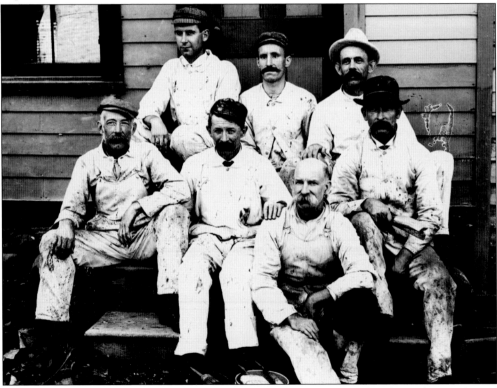

House painters comprise this group of men. All dressed in white, they have their pails and brushes at their feet.

The artist is putting finishing touches on a portrait of Lyman Abbott, a local clergyman and author.

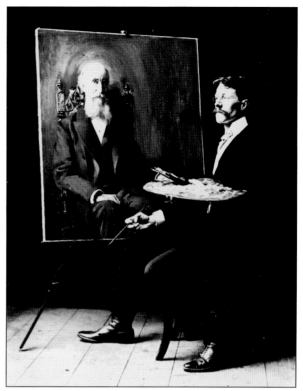

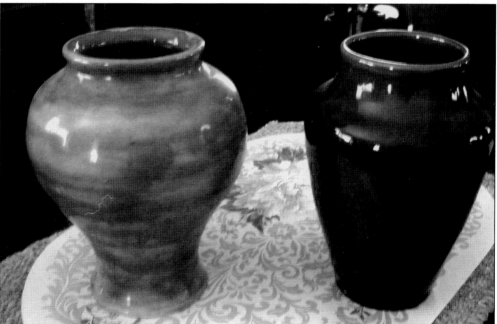

Louis Chivacheff went to Alfred University several summers, and one of the subjects he studied was the art of ceramics. It led to his later election as president of one of the Hudson Valley art organizations and his demonstration at an annual convention. The vases that he made belong to his grandnieces Doris and Jane and were photographed by Bill Fulton.

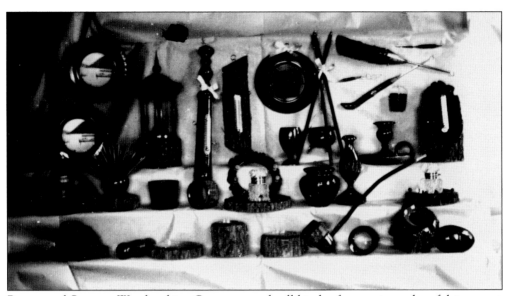

Barton and Spooner Woodworking Company made all kinds of souvenirs and useful items out of wood from Storm King Mountain. The factory was on one side of the building, and a shop for sale of items and postcards was on the other. It is a private home on Duncan Avenue today.

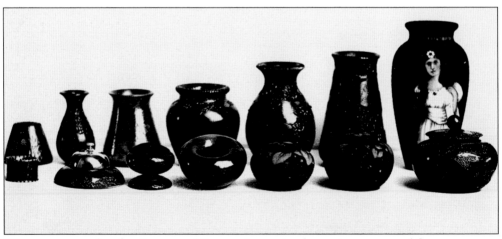

Women were employed at Barton and Spooner's to paint decorative scenes and flowers on vases and other products. Young men were paid to shellac the pieces, some of them to be sent to Macy's in New York City for sale. Leo Fanning remembered this early morning job and then walking to school with the strong smell still in his nostrils. Fanning grew up to become the only village policeman needed in Cornwall-on-Hudson for many years.

Louis Chivacheff cleverly placed this unusual clock next to a ruler to show its height of 15 inches. Some pieces were made with the bark left on for decoration. The clock can be seen in the top picture of the previous page amid the nut dishes, buttonhooks, picture frames, pipes, candleholders, and other items.

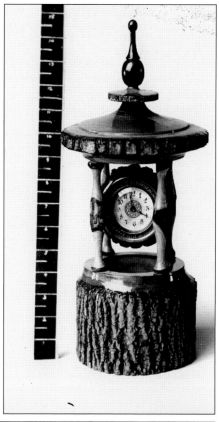

The presses seen here are typical of those used in printing. The *Cornwall Local* weekly newspaper operated from three different addresses in the village before moving to the town. One of the moves involved the exciting delivery and set up of new and more modern equipment.

The Elmer House Hotel became the Wheeler Sanitarium under the direction of Dr. Asaph J. Wheeler. He had his patients moved from Craigclare in Sullivan County and advertised a free 30-day treatment to anyone bringing with them a copy of his advertisement in the *Cornwall Local* in 1905.

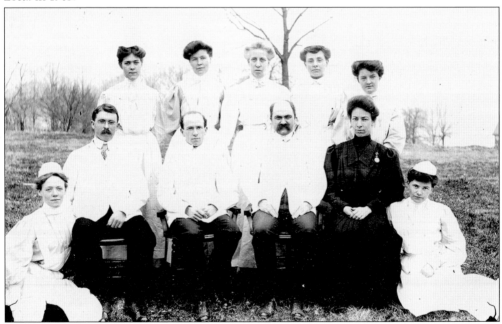

Taken in May 1906, this image shows Wheeler seated on the left followed by his assistant, C. Arthur Ackerly; Dr. Hubbell; his secretary, Miss Lathrop; and seven nurses. The startling news of his suicide note found on the steamship *Hartford* in January 1908 was announced. No body was found, and one local person claimed that Wheeler could probably be found in Brooklyn being entertained by one of his lady friends.

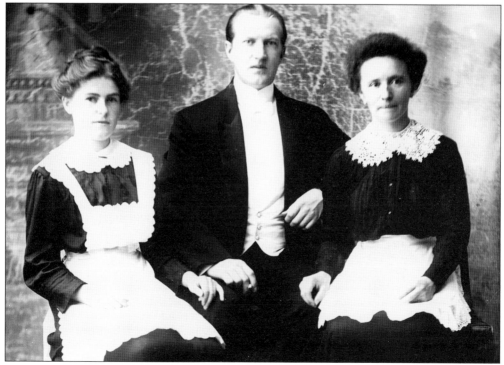

Pictured are some of the domestics employed at the local hotels and by owners of the mountain estates. Louis Chivacheff seemed to enjoy capturing a part of everyday life.

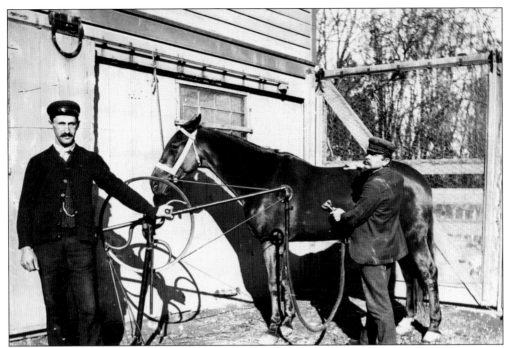

The daily chore of currying a horse was hard work for owner or caretaker. The modern hand-cranked invention seen here saved time and muscle.

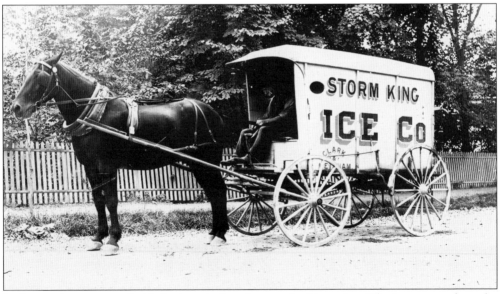

Ice harvesting was a profitable business before the age of refrigeration. The ice was cut from the frozen Hudson River and from local ponds and then stored blanketed in straw until needed in the warm weather. Ulysses Grant Clark and Jay Ketcham formed a partnership in 1899, built and filled an icehouse on the Sagamore House property, and are ready to make a delivery in the handsome Storm King Ice Company wagon.

T. J. Dwyer was a local nurseryman who offered pot-grown strawberry plants, fruit and ornamental trees, vines, shrubs, and landscape services. The nursery introduced the new strawberry E. P. Roe, named after the resident author Edward Payson Roe. An advertisement appeared in Addie Wright's *Standard Guide of Cornwall* in 1898.

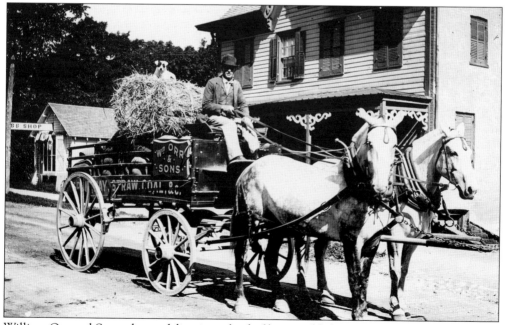

William Orr and Sons, shown delivering a load of hay, could also provide animal feed and coal to its customers.

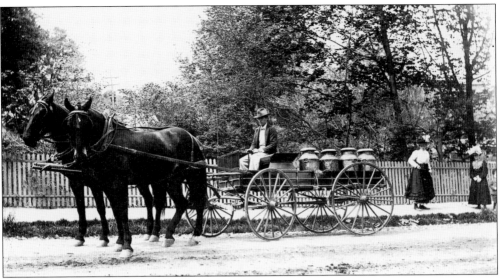

Ladies in large hats and a young boy watch the milk wagon pass by. The many Cornwall farms could supply much of what was needed at the boardinghouses and hotels, and delivery was made at the door.

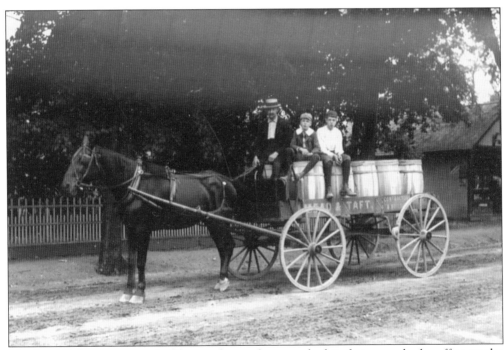

Mead and Taft, contractors, builders, and manufacturers, had its factory and sales office on the Hudson River at Cornwall Landing. It also carried hardware, household goods of all kinds, and Flexible Flyer sleds. The wagon here is making a delivery through town.

Four

PEOPLE AT PLAY

Who can imagine life without radio, television, and computer games? Cornwall-on-Hudson residents are pictured at the pastimes that gave them pleasure. Ladies in long skirts enjoyed croquet, lawn tennis, and picnic hikes on the Storm King Mountain trails. They dipped their toes in the creeks and streams and in the winter went for sleigh rides. Bicycling became an active sport shared with the men, and basketball games at school were most competitive. Men participated in football and baseball games and boating. Cornwall, Cornwall-on-Hudson, New York Military Academy, and the Stone School (now called Storm King School) all wore at certain times athletic jerseys emblazoned with a large C for Cornwall.

A bicycle club was organized in 1894 with the following charter members: Rev. G. D. Egbert, attorney H. W. Chadeayne, Dr. Goodman, Isaac M. Cocks, William B. Taylor, and Miss H. Cocks. Initiation fees were $1, and monthly dues were 25¢. The next June Elizabeth Cocks, Eva Lawrence, and Grace Richards joined, along with George Bliss, James Richards, John W. Spencer (Louis Chivacheff's landlord), James Hall, and Ed Hunter. Several Cornwall basketball teams won championships, and Chivacheff was ready to record these events.

Music and theater were pleasurable activities. There were various types of bands in the town and village and at New York Military Academy. Concerts in the surrounding bandstands were scheduled in each community on a different night so one might fill the week with music. Many a courtship developed during these happy occasions. Musicians from John Phillip Sousa's band sometimes visited Cornwall-on-Hudson and would give an electric performance in the village bandstand always reported in the newspaper. Dramatic and comic plays were well received, along with slapstick and minstrel shows. People seemed to enjoy getting dressed in outlandish costumes and acting. Those not so inclined formed an enthusiastic audience. Lectures, stereopticon presentations, roller-skating, and dancing were entertainments at Opera Hall Rink on Duncan Avenue or Library Hall auditorium on Idlewild Avenue. Summertime offered a variety of church and organization fairs and occasionally a circus or gypsy camp would come to town. Life was good, at least for those with few responsibilities.

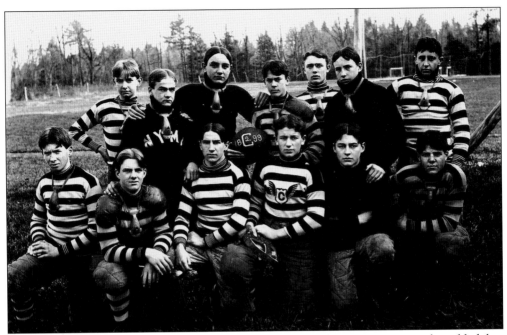

Members of the New York Military Academy football team of 1899 were not overly padded, but notice the nose protectors hanging from their necks in the first photograph and in place for the scrimmage in the second one.

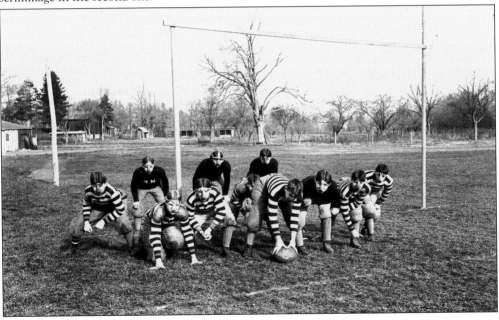

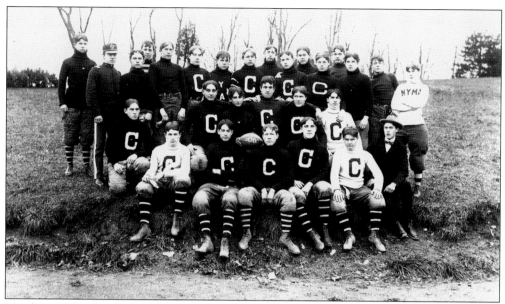

Members of the New York Military Academy team of 1900 were champions and posed with their leaders. The private school educated students interested in military careers.

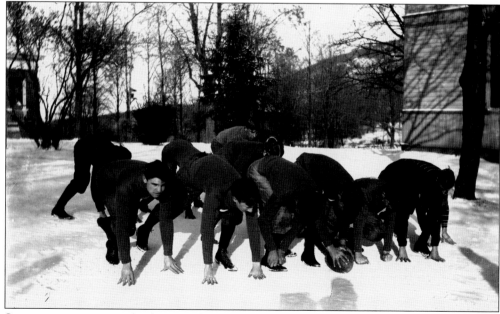

Sometimes practice took place in the snow, and this photograph shows the image of the photographer and his camera in the foreground. While football was a rough game, notice that only one fellow is wearing a helmet. It would be some years before numerous injuries awakened the need for more protective equipment.

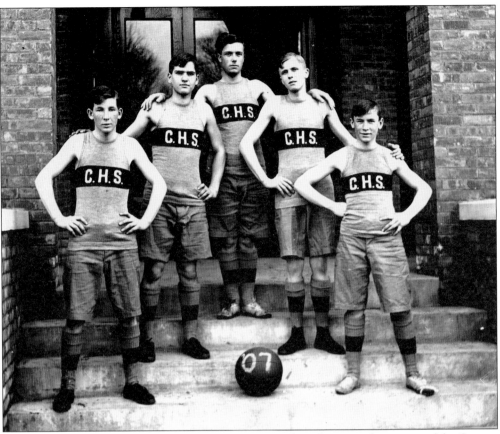

Cornwall High School basketball players enjoyed a number of years as champions of the Orange County League, one of them in 1907. Competition was fierce among the young men, and they participated against county schools that drew from a much larger student population. It was all the more gratifying when a championship was won, and the names of the team members would be recalled and the games recounted with much enthusiasm for several generations.

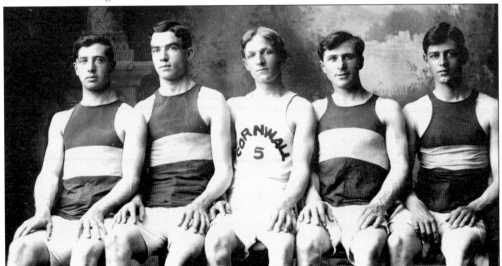

The baseball player with the name Firth emblazoned on his shirt was a member of the team sponsored by the Firth Carpet Company. The company was very family oriented and promoted all sorts of activities and sports for the enjoyment and relaxation of the employees. Families were gathered to pose for very large panoramic photographs in later years at the annual family picnics. The Cornwall Historical Society owns many of the photographs and welcomes people to visit and help identify ancestors who worked for the company and attended the picnics.

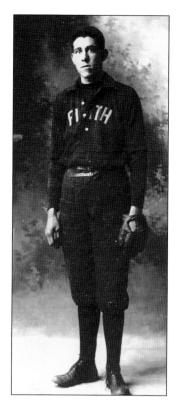

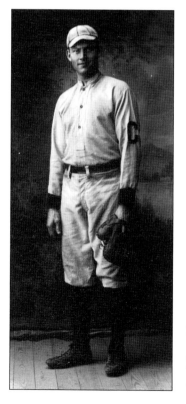

Baseball was a favorite sport. Thomas Weeks, C. Stillman, R. Pagenstecher, and others who donated the land for the playground during the Hudson-Fulton Celebration of 1909 continued their encouragement of athletic sports for young people. It was their idea to have a loving cup made to be awarded to the best players between Cornwall-on-Hudson and Highland Falls schools in the sports of baseball, basketball, and hockey. Rules were soon enacted requiring the teams to win two out of every three games.

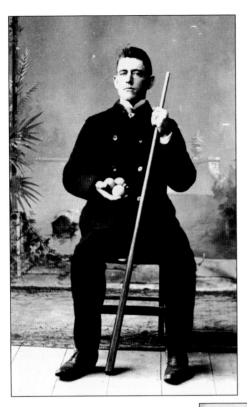

Cornwall-on-Hudson can boast being the birthplace and residence of famous billiard player Willie Hoppe. He learned how to play the game as a young lad standing on a wooden box at his grandfather's hotel. Julius Hoffman was the grandfather who at one time had a bottling works at Cornwall Landing and then later operated the hotel where Hoppe became proficient at billiards.

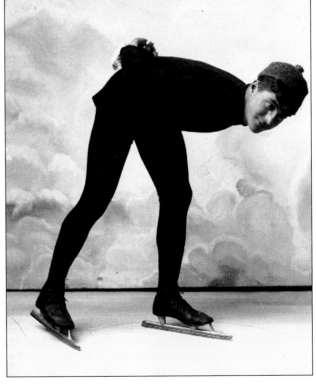

John Donaghue was a Hudson Valley competitive skater. Leo Fanning knew him well and once raced with him. There were skaters who went from Cornwall or Newburgh on the frozen Hudson River all the way to Poughkeepsie. Another well-known racer was Clarence Clark of Storm King who won $25 for a race won at Verplanck's Point. He was a great athlete on the bicycle also.

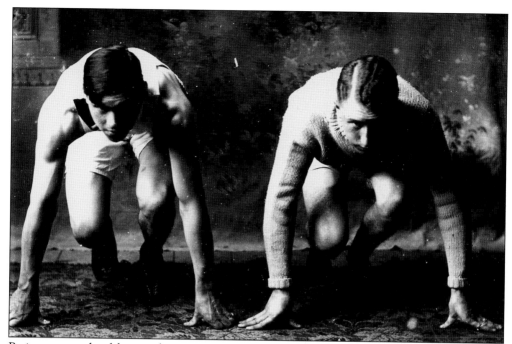

Posing two track athletes indoors was a unique idea. Here one can see the backdrop of marble pedestal, trees, and scenery behind the men and the flowered carpet beneath. They appear often in images Louis Chivacheff took.

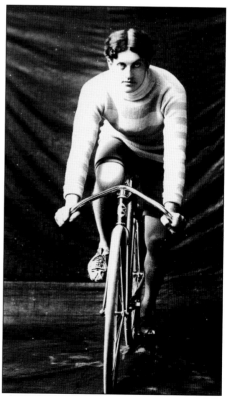

A dark cloth was hung behind this competitive racer. Note the shoes he is wearing. John Barton of Mountainville was practicing daily at Opera Hall Rink in December 1893 to prepare for a six-day bicycle race to be held in Madison Square Garden. He raced over 1,000 miles in January 1894 but did not win. "Columbine," the nom de plume used by a woman reporter in the Cornwall hamlet of Mountainville, reported in the weekly newspaper that "Barton was the most graceful and easy rider of all despite the fact that he lost the race."

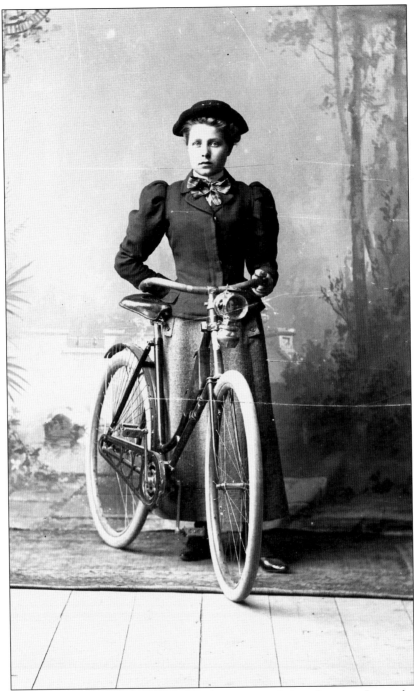

Biking became a fashionable sport, at first only accommodating the men. Later the bar was removed to make it easier for women to mount, and a cover was placed on the chain to protect their skirts from getting caught. Of course, bloomers were the real helpful solution to this problem, but many women were not ready to wear them. This bicycle sports a light, which became a necessary item according to a village ordinance of 1895 if bicycles were used after dark.

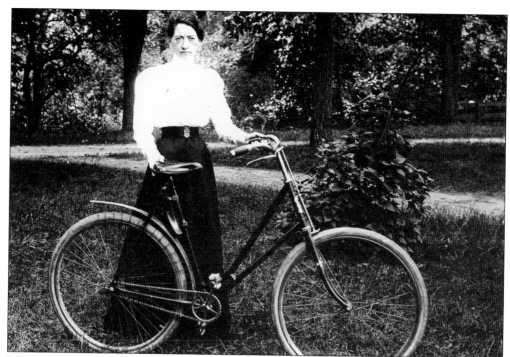

The proud owners of the bicycles here are dressed for riding, he with his bow tie and cap, and she with a cinched waist. Local businesses were beginning to add bicycles to their stock. Gilbert Cocks sold five Tribune bicycles in March 1903. Columbia, Victor, Whitten Godding and Company, Union, and Hartford were some of the makes. Bicycle slang was in use by 1895: an awkward person was a "wobbler," a gossip travels with a "loose sprocket wheel," and if one's clothing was not in style, he or she was a "95 model."

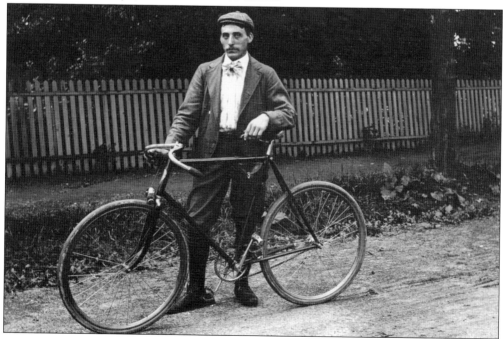

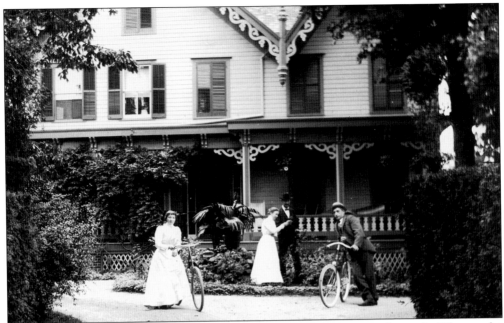

Boardinghouses encouraged healthful activities, and this group prepares for a ride. Bike parades were also a popular pastime, and one was advertised for August 1896. Bicycles were not allowed on the sidewalks since the state law of 1887 that prohibited such use.

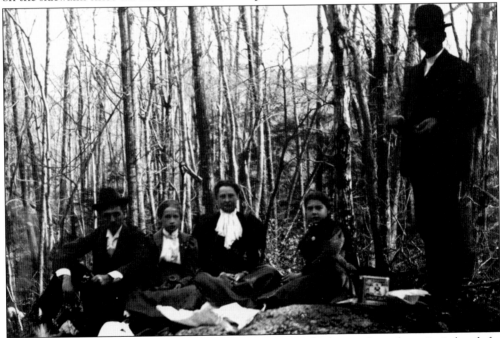

The hike up Storm King Mountain was a strenuous one, and everyone brought a picnic lunch for the rest at the top. It must have been difficult hiking in the clothing seen here, but the view of the valley and river was surely worth it. For those not up to such a hike, a photograph of Storm King Mountain, mounted in a very pretty frame that was made from wood from the mountain, could be purchased at H. L. Barton's on Duncan Avenue in 1897.

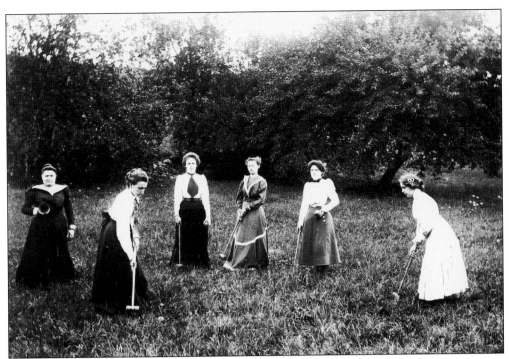

Ladies were fond of lawn tennis and croquet. Note the lady on the left of the croquet team ready to ring her bell. The Cornwall Mountain House and Cedar Lawn were two of the places advertising lawn tennis grounds in their travel brochures.

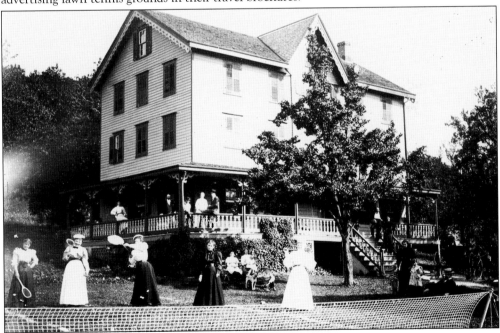

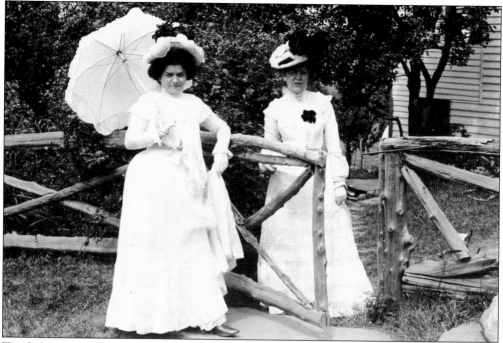

Two ladies in white are sporting hats and a parasol for protection from the sun as they stand by the quaint garden gate. Louis Chivacheff liked to pose natural scenes such as this as much as any indoor formal portraits.

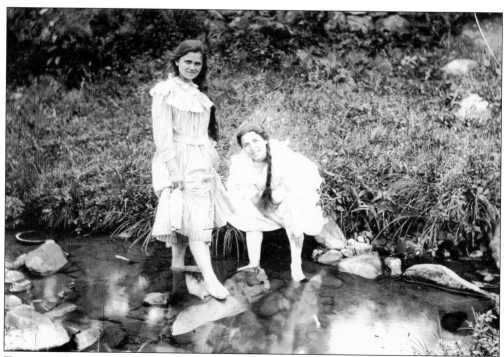

Two young ladies, more casually dressed than those in the previous image, dip their toes in a local stream before the days of swimming in bathing suits.

There were many fruit trees and orchards in Cornwall and plenty for two ladies in high-necked waists to gather in their skirts. Several boardinghouses made known the fact that fresh fruit and vegetables were grown on their property, and it was a drawing card for many city folk.

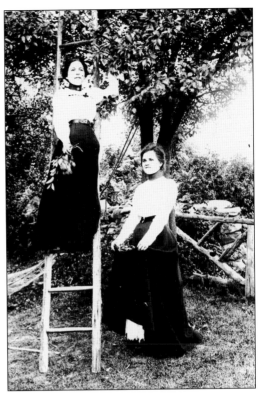

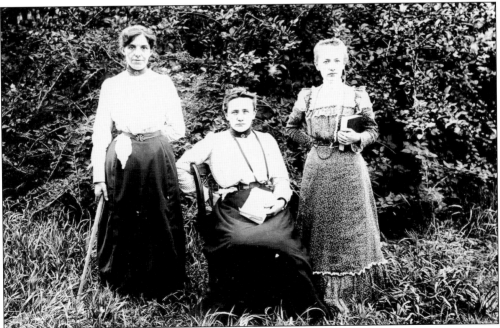

There were always hotels guests and local residents who just preferred to relax with a good book, which is the joy of present-day women as well. Cornwall-on-Hudson was the home of many authors, Amelia Barr, Edward Payson Roe, Nathaniel Parker Willis, and Lyman Abbott among them.

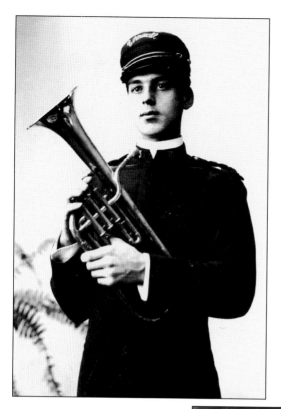

Both the town of Cornwall and the village had cornet bands. All members wore caps embroidered with *Cornwall*. The Cornwall Village Band was organized in 1881 with 14 pieces and soon reached 28. When the architecturally charming Mead and Taft bandstand was constructed in the square, the band played one evening each week during the summer.

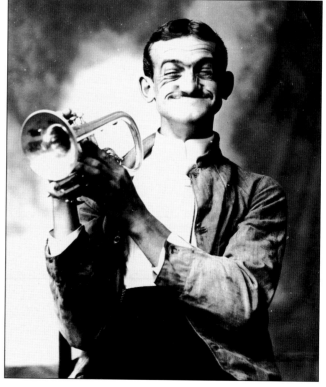

This image shows a trumpet player mugging for the camera and enjoying it wholeheartedly. Bandstands in surrounding communities planned their concert schedules so that one could hear music every day of the week. Many a romance was developed when a fellow took his gal for a buggy ride to the concert in the next town.

A more serious, formally dressed musician is seen here. The *Cornwall Local* newspaper of June 1898 reported that Cornelius Higgins and family were summering again at Dean's Cottage at Cornwall Landing. "Cornelius' son, Henry A. Higgins, cornet player with Sousa's Band, will perform with the Village Band. Arthur W. Pryor, world champion slide trombone player is visiting Higgin's family and will play with the Village Band as a special feature."

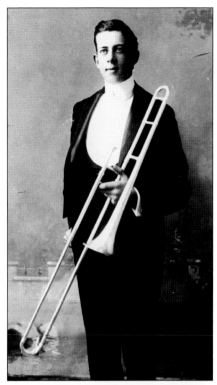

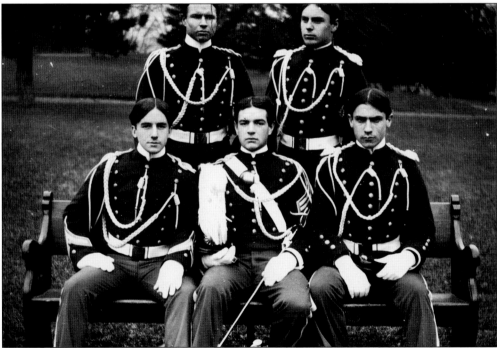

The New York Military Academy had a band of its own, and of course, the uniforms were elegant and in the likeness of those worn by the cadet at the United States Military Academy at nearby West Point.

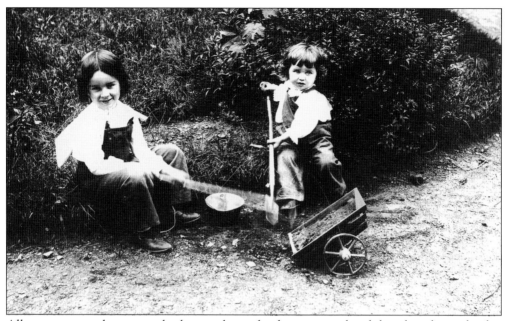

All youngsters to the present day love to dig in the dirt, use a pail and shovel, and cart the dirt away in a wagon of some sort. One boy also has a flashlight.

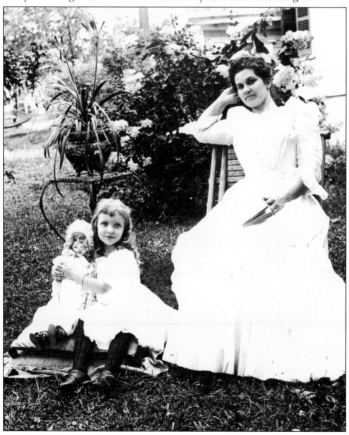

As a mother relaxes with a book, her young daughter hugs a beautifully dressed doll. Note the indoor plant brought outside for the summer sun.

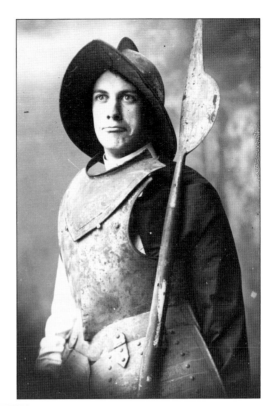

Acting and performances of all kind were great fun for village residents. Here an armored warrior tries to look serious before pretending to cut off someone's head.

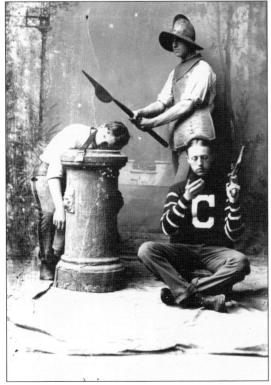

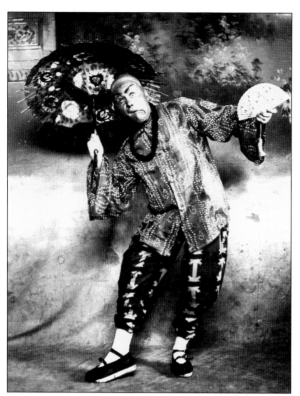

Jimmie Ransone portrays Behung-Bi-Bi in a play at New York Military Academy in 1905.

Can anyone guess who is in costume here? It is none other than Louis Chivacheff himself.

Five

How Did They Get There?

The automobile industry had not yet made a tremendous impact in Cornwall, although one local blacksmith was building another barn and looking into a dealership. A car was a luxury, sometimes feared, noisy and dirty. It would bring about changes in women's clothing and new laws on the village books. Most of the citizenry was content with their buggies and wagons, although one certainly needed a barn to store the equipment and a stable for the horses. Some churches and places of business had carriage sheds to accommodate the vehicles and protect them from inclement weather. Tom and Mary Ellen Quinlan of Shadow Mountain Farm (built by sloop captain Jacob Smith and later known as the Hand Farm) own a spindle buggy. The receipt dated 1893 lists the cost as $65. Additional charges were $2.25 for a blanket, 50¢ for a brush, 50¢ for a whip, 25¢ for a currycomb, and 75¢ for a lap blanket.

Nicholas Cocks and Sons established their carriage business in 1859 and were successful for 17 years. The firm then became Cocks Brothers and occupied five buildings along the creek on Main Street. They were careful in the selection of materials, using only the best seasoned wood and first quality of iron and steel. The different departments composing their business included the blacksmith shop, woodworking, wheelwright shop, painting, trimming, and finishing. George Kent advertised in the 1890s well-ventilated stables behind the Elm Park Hotel. He boarded horses and kept a nice stock of saddle horses ready for use; did all kinds of team work, plowing, harrowing, and carting of all kinds; and also ran carriages to meet all incoming trains and conveyed passengers to their destinations.

Young children could enjoy a ride in a cart or wagon pulled by a dog or goat as well as a pony. Finally the automobile arrived in Cornwall-on-Hudson and Louis Chivacheff was on hand with his camera to record the moment.

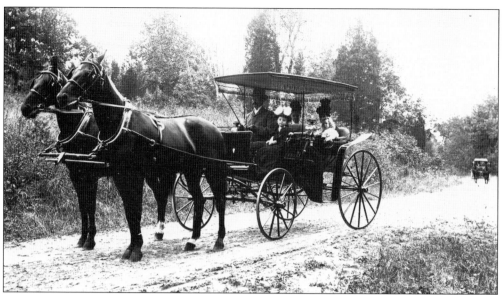

A family riding in a surrey, with fringe on top and sidelights, might be on their way to church, and they appear again on their return. Notice the buggy following behind on the dirt road. An 1897 surrey like this one could be ordered from Sears Roebuck and Company for $87, and Cocks Brothers of Cornwall advertised in 1892 that they could build to order all styles of light carriages and sleighs of the best quality at reasonable prices. A surrey like this one weighed about 500 pounds with a capacity of 800 pounds.

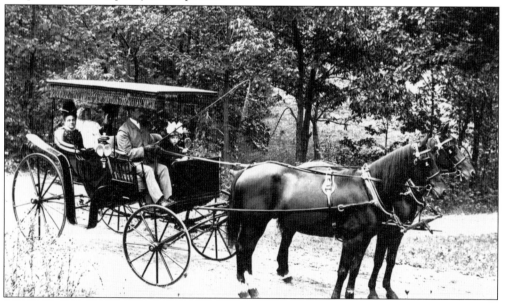

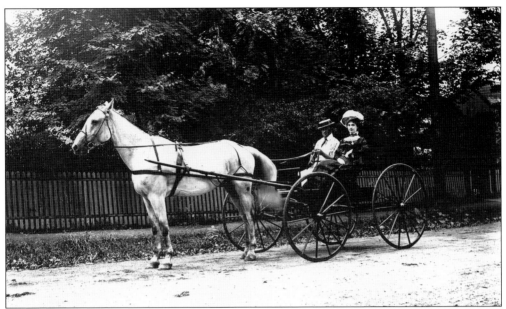

A happy couple sits in a buckboard drawn by a white horse along one of the properties on the main street. This style vehicle could be purchased for about $35 with a solid panel back, built on elliptic end springs, and a body 24 inches wide and 50 inches long.

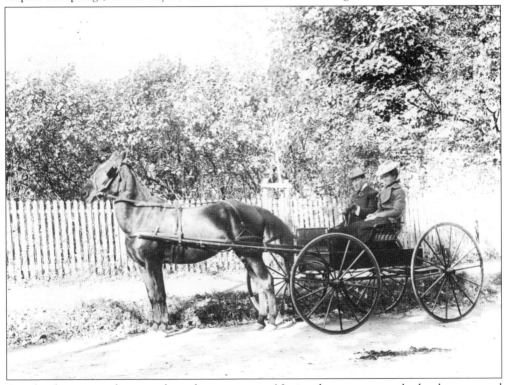

Another happy couple poses along the same street. Notice that young trees had to be protected with staking to keep the horses from nibbling on them. A buggy of this type weighed about 300 pounds and had a 500-pound carrying capacity.

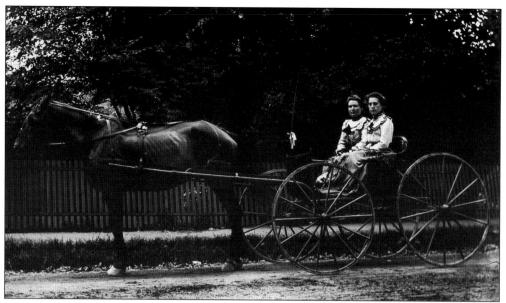

Two ladies pause in a spindle buggy like the one owned by Tom and Mary Ellen Quinlan of Shadow Mountain Farm that sold for $65 in 1893. Take notice that there were dirt sidewalks along the main street, but walking in long skirts after a rain was a messy affair.

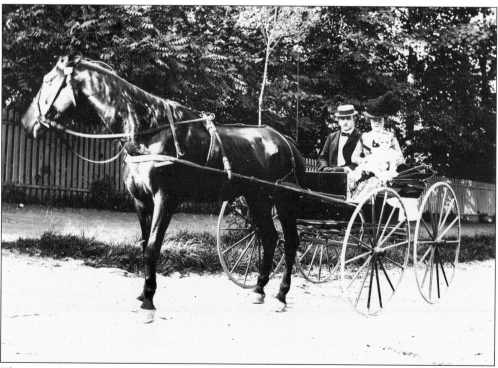

The young family in the top buggy, which provided protection from inclement weather or the sun, would rather show off the fancy headwear and baby girl. Buggies that were purchased from Cocks Brothers dealt with a business in operation since its founding in 1859 by Nicholas Cocks.

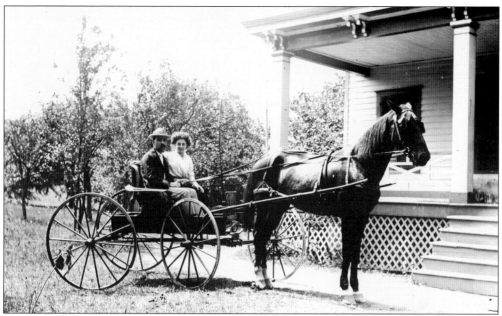

A couple returns home after an outing along Cornwall roads. Reins and harness were additional equipment needed for a buggy ride. How many romances flourished while clip-clopping along some secluded paths?

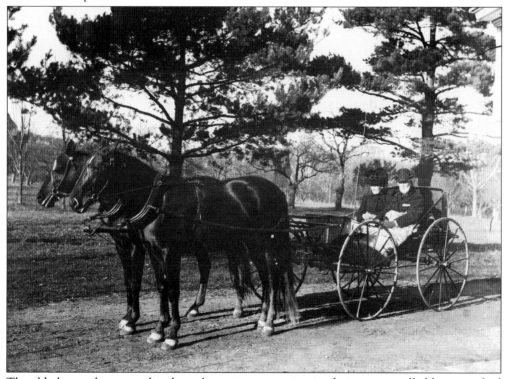

The elderly couple wrapped in lap robes enjoys an outing in their wagon pulled by a matched pair of horses. Winter weather required additional clothing and ember-filled foot warmers before the days of automobiles with heaters.

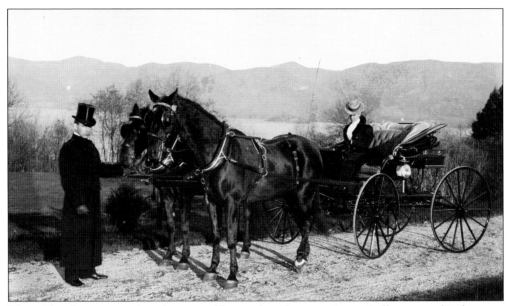

The spider phaeton seen here has a rumble seat for a footman. James Stillman sent his footman for instruction when automobiles came into fashion, but many people who could afford the first cars found out that they were not always dependable. The Hudson River and mountains on the east are seen from the higher elevation of the property in this photograph.

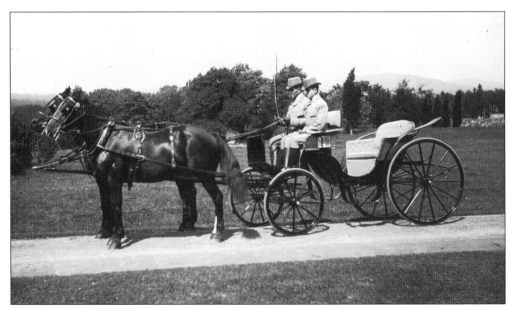

Two dapper gentlemen in boots and derby hats pose in a handsome cabriolet. Lewis Beach in his book *Cornwall*, written in 1873, states that the walks and drives about Cornwall are not only numerous but charmingly pleasant.

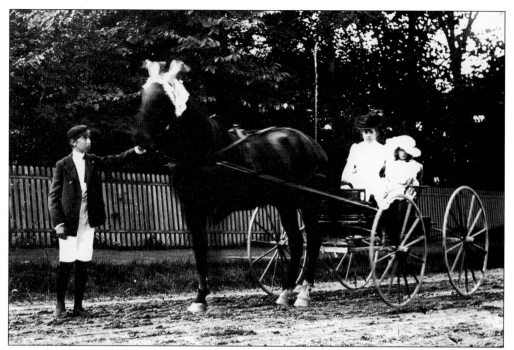

Young boys learned to handle horses at an early age. The boy here holds the reins while mother and daughter pose in their fancy hats. Perhaps they were headed to the Cornwall Landing, where equipages of every kind greeted the passengers arriving by boat.

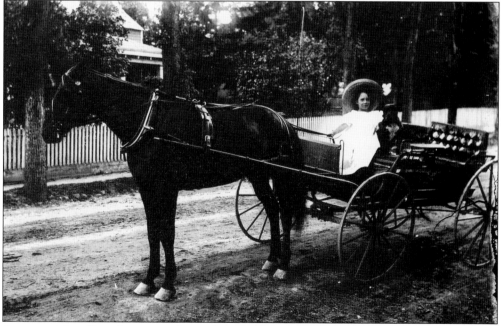

A young girl and her dog are out for a ride in a pleasure wagon. They are parked in front of the early Clark house, built around 1750, that was opposite Louis Chivacheff's house and studio. Ray and Jane Odell bought the house, and Bettyjane grew up there. Who could have guessed that Chivacheff's legacy was right under her nose all those years?

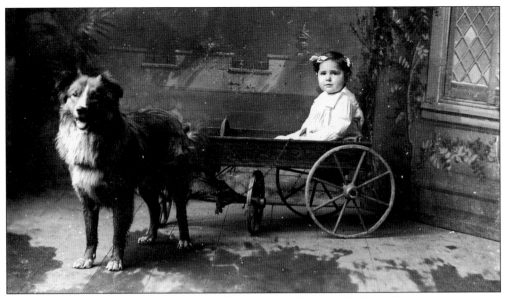

Children had means of transportation all their own. The sturdy dog pulls his mistress in a wooden wagon.

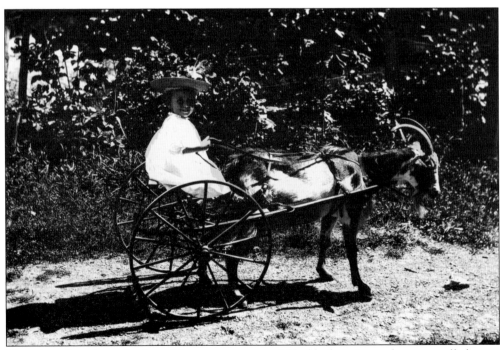

There is no happier smile than this one, as a young girl holds the reins on her goat-pulled cart.

The pedal car shown in this photograph of three children indicates a wealthy family purchase imitating the newfangled automobile.

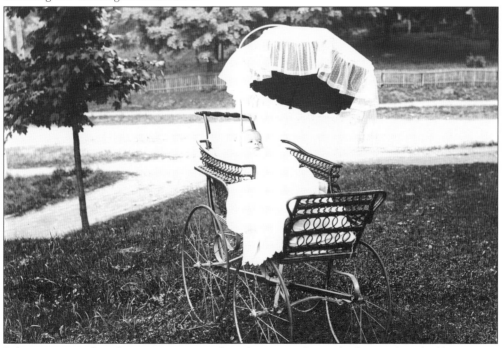

Babies got around in elegant carriages, such as this one with attached parasol, pushed by a nanny or doting parent. A similar carriage cost $8 from the Sears, Roebuck and Company catalog and three times that amount if purchased in New York City.

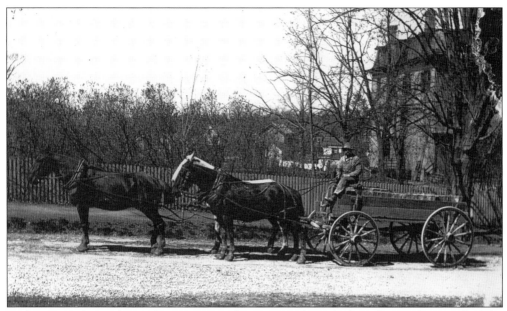

A three-team horse-drawn farm wagon makes its way through the village. The sound of the clip-clop of horses' hooves was daily music to 18th- and 19th-century America, one sadly missing from sounds of today.

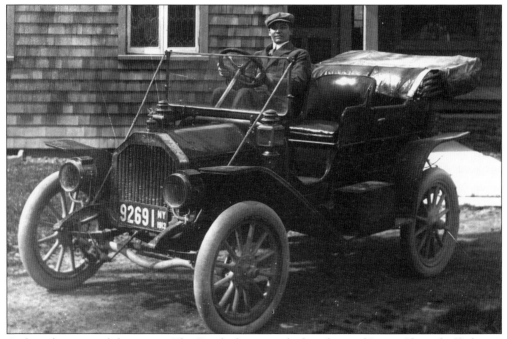

At last the automobile arrives. The Buick shown parked in front of Louis Chivacheff's house sports license plates dated 1913. The first cars were allowed to reach the speed of 8 miles per hour in Cornwall-on-Hudson. It was later increased to 15 miles.

Six

FAMILIAR FACES
AND PLACES

The Clark twins, Antoinette and Marion, were born in 1900. Their father, Henry Newman Clark, was a village pharmacist. He also served as village treasurer, president of Cornwall Savings Bank, and a member and officer on the board of education and the board of health in Cornwall-on-Hudson. His wife, the former Nellie Chase, was the daughter of the school principal. The homes of both families are on Clark Street. They could well afford the services of a professional photographer, and Louis Chivacheff captured the twins from infants in a baby carriage through their preteen years.

Wedding photographs were always a favorite, with large hats the fashion rather than long veils. John Kinsler married Sarah McMahon on June 19, 1907. She came to Cornwall on the famous *Mary Powell* steamboat when she was seven years old. Seven children were born to them, and all grew up to be active citizens. Some of their descendants call Cornwall-on-Hudson home. Ray Fulton sat for the photographer in 1916 just before his marriage to Marion O'Neil. She had come from Hudson to Cornwall during the Hudson-Fulton Celebration of 1909 with her family. It was always a family story that she came from Hudson to marry a Fulton. Ray was born in Sullivan County and came here to work as an electrician during the construction of the Storm King Highway and because of delays ended up working for a telephone company and later Central Hudson.

A well-known Cornwall philanthropist was Erard A. Matthiessen. He purchased land in the village and built the first rental properties. Five houses were erected on Pine Street in 1879, and the success of his endeavor led to the construction of 10 more houses in 1898. He had been responsible for the building of Library Hall earlier, a subscription library open to paid members. The first floor of the edifice was rented to businessmen, and it was here that Henry Clark had his pharmacy. Matthiessen built a bank next door to the Library Hall on River Avenue, and after one of the employees absconded with the money, he closed the bank and gave it to the village for its corporation rooms. The village office remained there for many years.

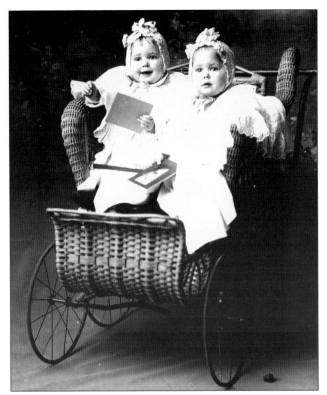

The Clark twins, Marion and Antoinette, smile for the camera in their wicker carriage. The first Clark settlers came to Cornwall from Bedford in 1748 and purchased about 500 acres from Mary Ingoldsby. The girls attended a business school in Poughkeepsie, and they grew up and became secretaries in New York City, in the days when a good secretary was a businessman's most important asset.

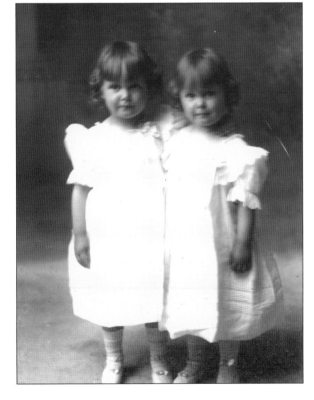

Out of the carriage stage, walking now and somewhat older, the twins display innocent charm. Their father, Henry, was advertised in the *Standard Guide of Cornwall* in 1892 as a druggist and apothecary. His store carried pure drugs, medicines, chemicals, toilet and fancy articles, books, stationery, cigars, soda, and mineral waters.

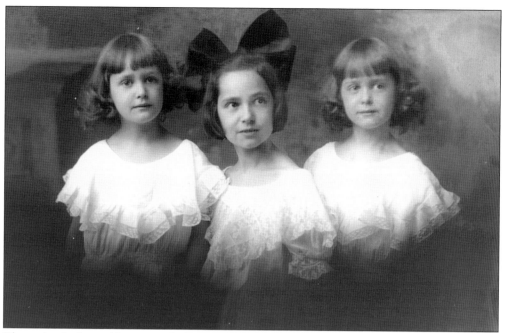

The twins had an older sister, Catherine, and she poses with them in the center, a huge bow in her hair. A branch of the family migrated to Florida in the early 1800s and had an orange orchard. Catherine visited descendants of that branch who were her beloved Aunt Florida and Aunt Suwanee.

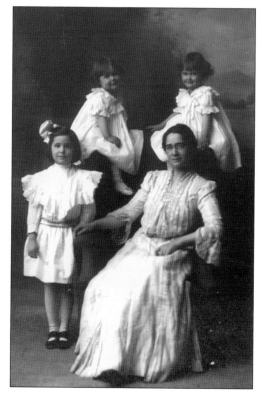

Mother Nellie Chase Clark joins this portrait. The Chase family lived on Clark Street, and Nellie's father was principal of the village school. When she married Henry Newman Clark, she only moved two doors down the street to his family home, which was built in 1843. It was there that their girls grew up, Marion being the last member of the family to live in the homestead.

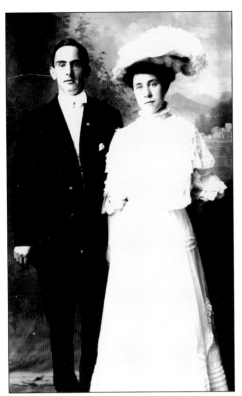

The wedding picture of Sarah McMahon and John Kinsler was taken on June 19, 1907. Sadly John died at the age of 45, leaving Sarah to raise seven children. Five of the boys served their country in World War II. All of them were musically talented. Loretta played the piano for the silent movies, and the boys formed a band that played for many local functions and just for pure pleasure.

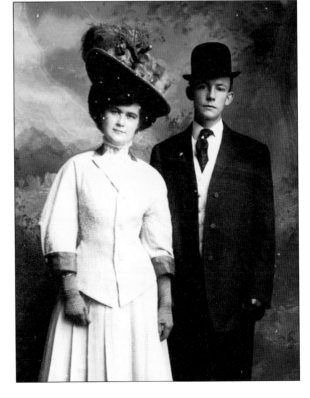

Here is another wedding photograph, the gentleman in a derby and the lady in a fancy hat with polka dots on the veil. Surprisingly, weddings were held on any day of the week, not the usual weekend, and businesses would close if the couple was well known and popular.

Ray Fulton came from Sullivan County to work on the Storm King Highway and boarded at the Elm Park Hotel, which can be seen on the Sanborn map. The daughter of the proprietor caught his eye, and they were married at St. Thomas Church in May 1916. The picture here was probably taken just before his marriage. He worked for the Central Hudson Gas and Electric Company, and when he later built a house on Spruce Street, he used the discarded lampposts for the support columns in the basement. His granddaughter and family occupy the home today.

Louis Chivacheff posed his wife, Alice, with some fancy hens. The clerical chair is one he often used in his studio.

George Chatfield (at left) and George Walsh were both veterans of the Civil War and were members of the Grand Army of the Republic (GAR), a veterans' organization formed after the war and the first national organization to admit black members. Chatfield was the proprietor of a boardinghouse called Cedar Lawn for a number of years.

Leonard Clark, a descendant of the early Clark settlers, grew up near the river and built all kinds of boats. One Decoration Day, he rented more than 70 boats for enjoyment on the Hudson River. He also erected three houses on River Avenue and made toboggans in the winter, which were used at the Cornwall Mountain House and even shipped to Scandinavia.

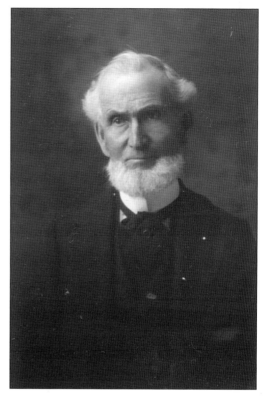

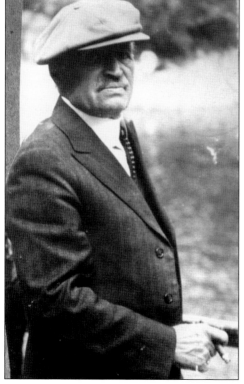

Louis Chivacheff sports a cap and his familiar cigar. He also walked with a cane by this time. One year just before Halloween, some mischievous urchins filled a pocketbook with stones and tied the handle with a string. They placed it on the sidewalk where they were sure Chivacheff would soon approach and as he did and bent to pick up the pocketbook they pulled it away with the string from their hiding place while trying to stifle their laughter. Such were the pranks that were often played on him.

The photograph here gives a look down Hudson Street toward the square with a buggy and delivery wagon in the distance. A tinsmith is advertised in one of the stores on the right side of the street. Oiling the streets was a necessary chore to keep the dust down in hot dry weather.

The village square shows Grant Clark's meat market on the corner of Hudson Street and Duncan Avenue. Note the corner of the bandstand on the right. When the power company was to erect a plant on the property, Clark just moved his building diagonally across the street, and the business continued there well into the second half of the 20th century.

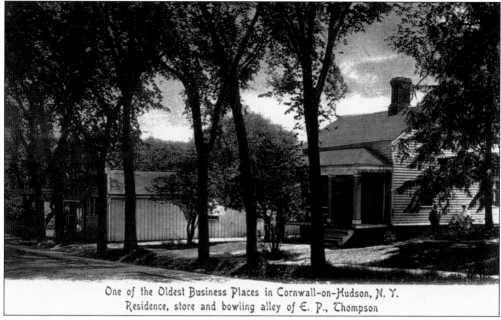

One of the Oldest Business Places in Cornwall-on-Hudson, N. Y.
Residence, store and bowling alley of E. P., Thompson

The 18th-century Clark house was owned by E. P. Thompson at one time, and he operated a store and bowling alley next door. The house was used on many postcards sold at Barton and Spooner's store, and it was directly across from the home of Louis Chivacheff. When Ray "Cap" Odell and his wife, Jane, purchased the house they witnessed the bowling alley become a bakery where Bettyjane Odell Costabel worked as a young girl. The interior of the old house has a charming fireplace and once boasted a large kitchen in the saltbox addition.

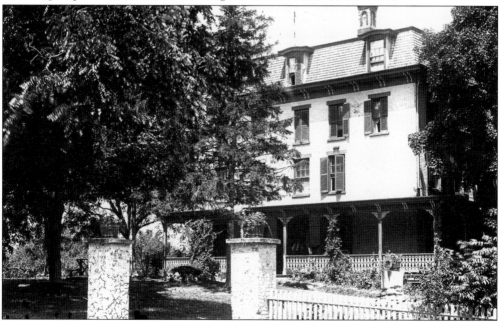

Across the street was another early structure that originally housed a private school. When Chivacheff was a neighbor it was called the Gold Cure Sanitarium, a place for treatment of alcoholics and drug addicts. Today it is an apartment building.

75

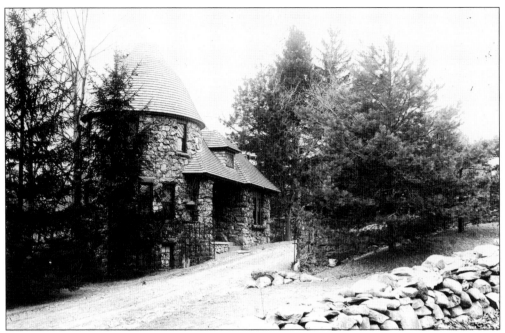

The quaint stone gatehouse was the entrance to the James Stillman house built by Mead and Taft in 1886 on Ridge Road. Today it is Joque's Retreat House.

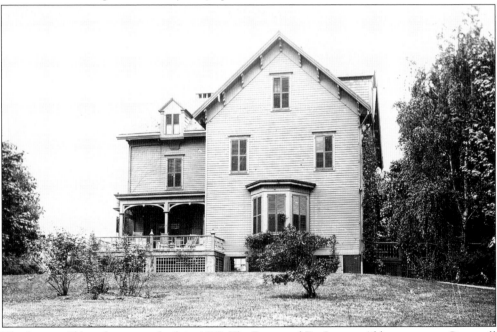

The Lyman Abbott house was built in 1870. The Reverend Dr. Lyman Abbott came to Cornwall in hopes that the pure mountain air would be beneficial to the health of his wife. He served as pastor at the Canterbury Presbyterian Church, was editor and writer for *Outlook* magazine, took an active interest in improvements in the community, was a strong temperance figure, and took part in national meetings at Mohonk Mountain House in Ulster County in the cause of Native American justice. He was a valued speaker at many of Cornwall's important functions.

The Grand View Hotel was a popular summer destination for people from the big city, advertised in the 1890s as "but ten minutes walk from the steamboat landing and the West Shore and Ontario & Western Railroad stations." Vehicles were provided, however, for guests who preferred to ride. A charming publication gives a diagram of the layout of each floor of the hotel. Guests could request a river or a mountain view or a northern or southern exposure. The lawns afforded unusual opportunities for out-of-door recreation, there were good accommodations for horses and carriages, and vegetable and fruit growth was under careful cultivation. "Every convenience that the refinement of city life demands will be found within the house."

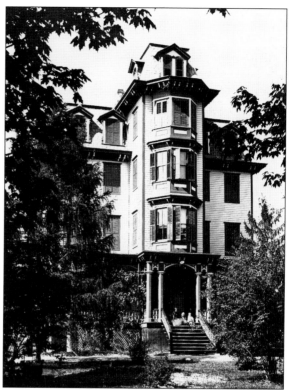

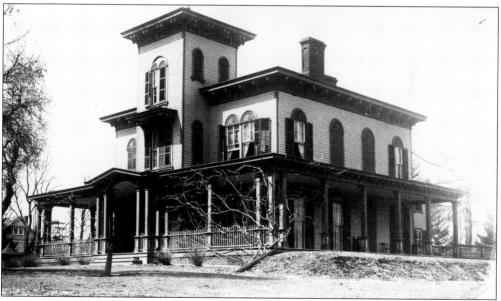

Called the Pines during this period of history, it had been purchased by Erard A. Matthiessen as his first home in Cornwall. He became a valuable resident who had the interest of the community foremost in his mind. He had founded the Corn Products Company in Chicago and was another man drawn to Cornwall for the health of his wife. He later built an elaborate summer home on the mountain and set up classes in this house to enrich those taught at the elementary school close by. In later years, Braden's Preparatory School occupied the building.

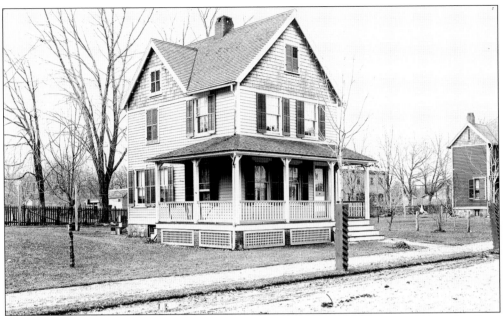

Erard A. Matthiessen had the unique idea that good affordable rental houses could benefit village residents. In 1879, he had the first of these constructed on his large acreage, and it became Pine Street.

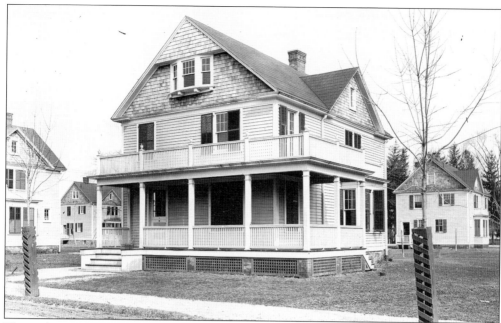

The endeavor proved to be so successful that in 1898 he had 10 more houses built, 5 on the opposite side of Pine Street and 5 on what became Spruce Street. The new houses were equipped with fireplaces and had plumbing and heating. Matthiessen died in 1905, and in 1913, the rental homes were up for auction; the bidders came from far and wide. Louis Chivacheff shows one house when it was very new and another after landscaped plantings had flourished, awnings were added, and happy residents gather round the porch.

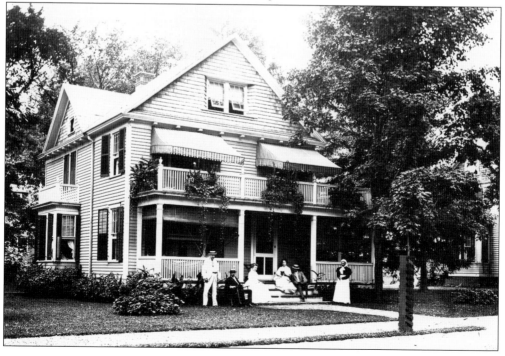

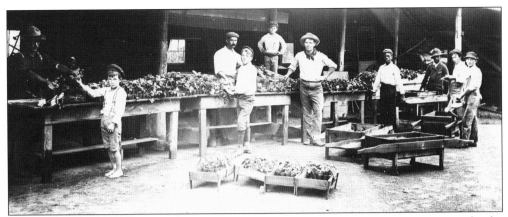

The men and young boys busy at the carriage shed appear to be sorting plants. They may be the pot-grown strawberry plants that T. J. Dwyer advertised or some other nursery plants that will be sold.

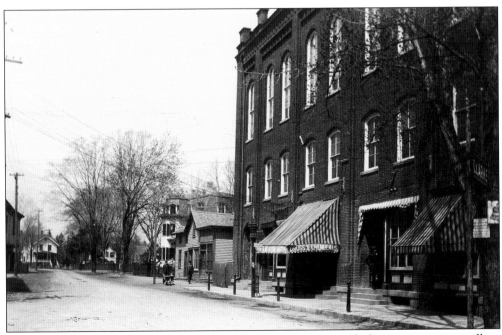

The well-known Clark's Drug Store operated by Henry Newman Clark, a man active in village affairs, is shown on the Idlewild Street location of Library Hall. Farther down the street the facade of a lovely Victorian house with a mansard roof protrudes near the sidewalk. It exists today, the building in between gone. A man pushes a wooden wheelbarrow, and a horse and buggy emerge from Churchill Street.

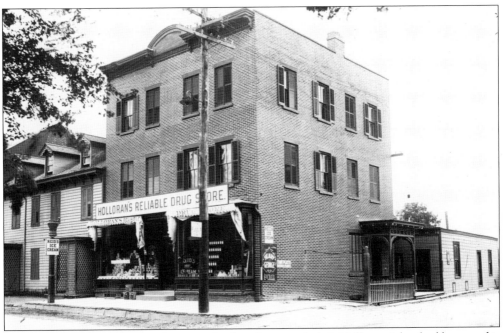

The town had its well-known drugstore. In this photograph, it is Hollorans's but had been and is called today by the name Hazard's and is owned by Deacon John Pelella.

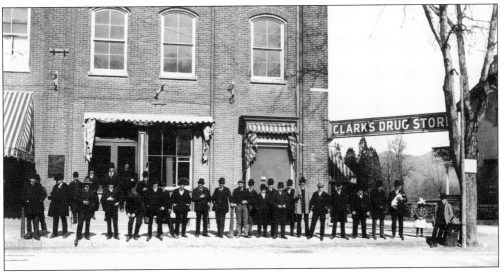

Another view of the Library Hall shows Clark's large sign on the corner of Idlewild Avenue and River Avenue. It is anyone's guess why all these well-dressed men are lined up in front of the building. There is also a young girl to the right with a large bow in her hair, and the fellow next to her is holding a dog.

The Methodist church on Main Street in Cornwall was constructed in 1830 and has had a number of additions. Before that time, the faithful met in a schoolhouse near Library Hall in the village. The parsonage has been recently renovated, and each winter, a live nativity presentation can be witnessed in front of the church.

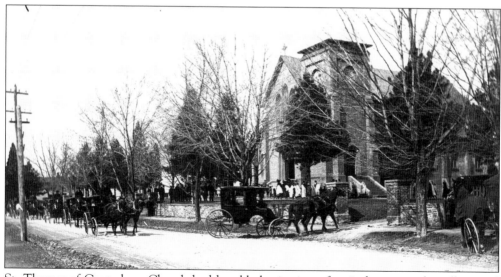

St. Thomas of Canterbury Church had humble beginnings, first in homes in the village and then in a small chapel on River Avenue. The cornerstone for this edifice was laid in 1871, but it was not completed and dedicated until 1882, when finances improved. It is winter as people in carriages approach the church to attend mass.

Seven

FASHIONS OF THE DAY

Beneath an attractive dress of the Victorian era was a corset boned and hooked or tied tight to enhance a small waist and improve the figure. Underskirts were more than three yards wide. The thought of washing and pressing the dress with a sad iron heated on a stove is incomprehensible today. Ladies felt they looked their very best and should have after such elaborate preparations, and they posed in groups or singly to show off their apparel. Hats were the rage, and the business of a milliner knew no bounds. It seemed that one fancy production was upstaged by one more outlandish. The enormous size of many of the hats must have been the source of numerous headaches. Why babies in their mothers' arms were not frightened is amazing.

While men patronized the several laundries in town to have their shirt collars and cuffs starched, they seemed to express their own fashion in facial hair. Beards and mustaches of all kinds were meticulously trimmed and treated, a great variety of styles existing. Some men's suits were quite dapper, and it was fashionable to show off a vest chain and charm as well as pocket watches. Even children wore elaborate clothing when dressed up. A young "Lord Fauntleroy" posed, and girls imitated their mothers while passing the fashions on to their dolls. Parasols were necessary to prevent fair skin from tanning, many quite fancy and ruffled. It was an era of excessiveness.

Social organizations had their particular dress. Masons wore formal attire for special functions, and the Knights of Columbus, a Catholic Church organization, wore regalia that included a sword and sheath. Young boys in short pants suits and gloves dressed their very best for the sacrament of First Holy Communion, and the girls were angelic in white frills, lace, and veil. The important day in the lives of these children occurred at beginning of the 1900s in the month of May when spring was warm and flowers abundant.

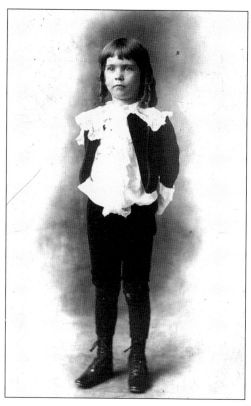

The photograph of a young "Lord Fauntleroy" was given by Allyne Lange and confirms the name of Louis Chivacheff's business as the original glass plate was found though badly damaged and unable to be reproduced. The other is of Mazie Ward, whose grandfather James was a brother to the famous oarsmen. She taught in the village school and elsewhere and in later years was chairman of the Constitution Island Association. She is seen here in a complicated dress design, a watch brooch, and with a bonnet larger than her entire head.

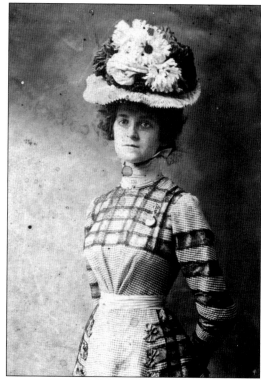

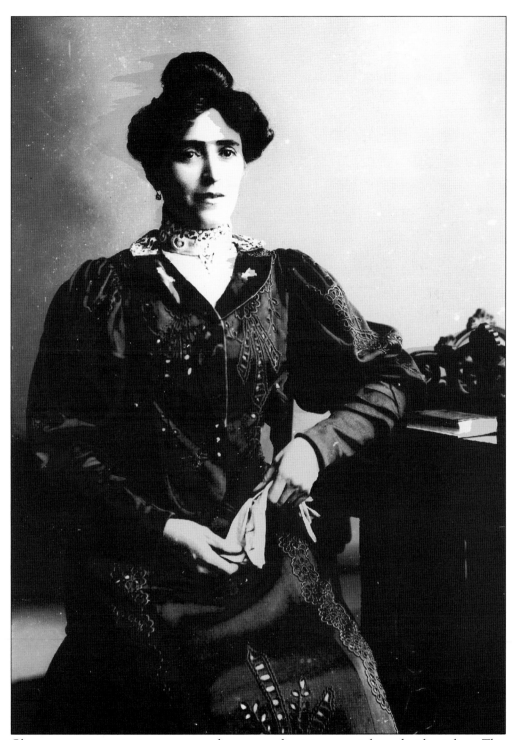

Gloves were an important accessory, and a woman of society was not dressed without them. This woman's upsweep hairstyle and bun shows off her earrings.

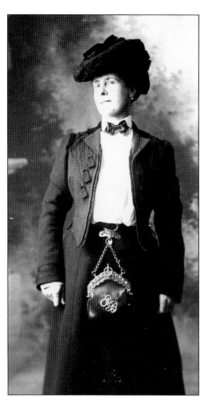

A masculine look in this pose shows a cap-style hat, bow tie, and suit jacket, but the unusual accessory is a belt attachment, called a chatelaine, to hold the initialed purse, leaving the hands free.

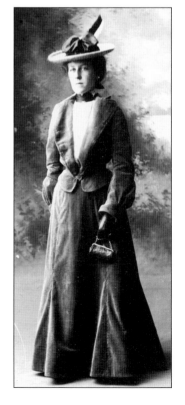

A corduroy ensemble, gloves, chain-held mini purse, and stylish hat help this lady join those who are dressed in the latest fashion.

Louis Chivacheff artfully poses this lovely lady by a potted fern. Her lace bodice vest is the accessory along with the watch or locket brooch.

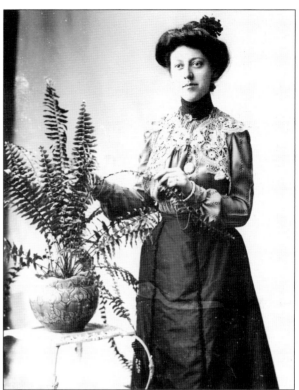

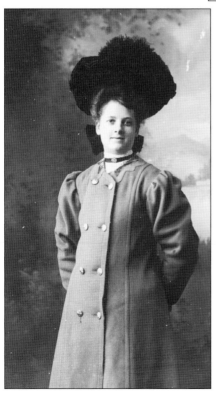

Dressed for cold weather, this woman displays a beguiling smile beneath a hat larger than her head.

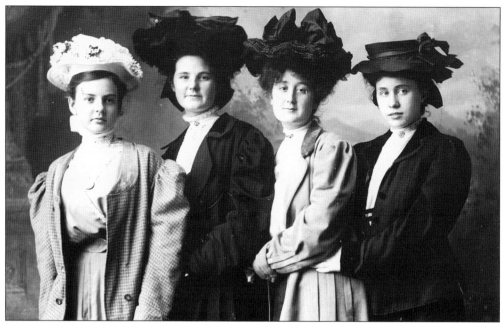

The four young ladies here are beautiful without a doubt. Dressed for fall, their hats show the wide variety of choices available. They wear automobile coats over their high-necked waists.

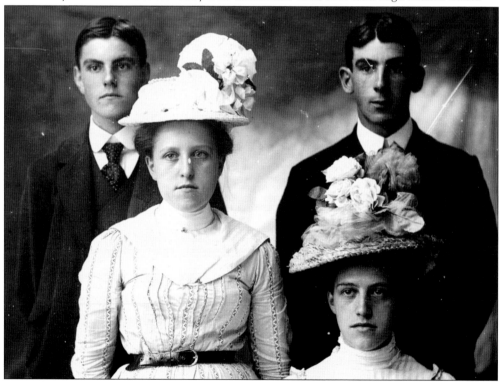

Two young men wearing starched collars are posed with their best girls in flowered chapeaus. How many men chuckled over the elaborate millinery or politely commented about the flowered chapeaus?

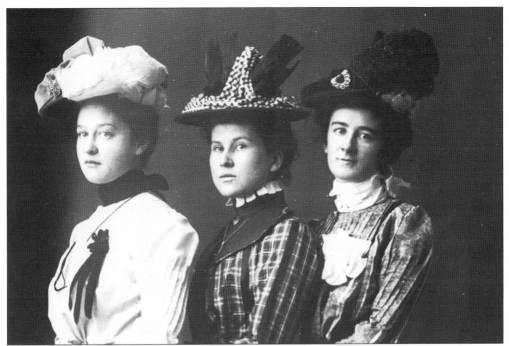

Attire for fall and winter is shown in these photographs. Some hats have decorative pins, and others seem to lift one in the air. The outerwear called automobile coats in the 1902 Sears, Roebuck and Company catalog sold in the $4 to $12 range.

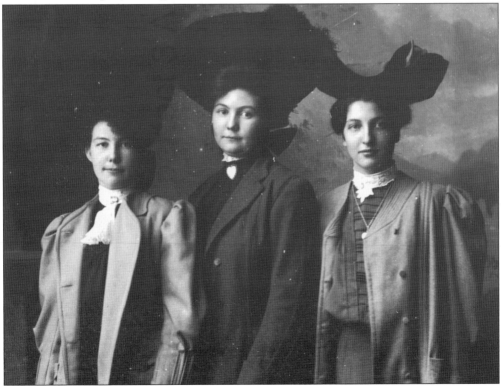

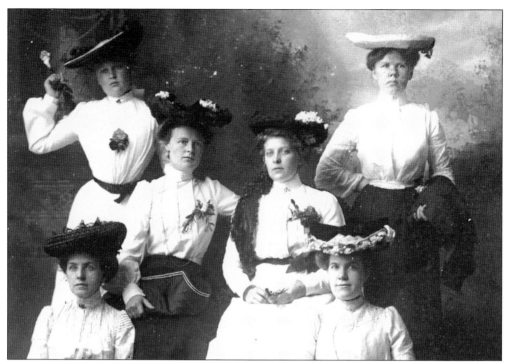

Six examples of hat styles and several corsages of flowers indicate a special occasion in the life of these ladies. Rather than pose them in a row, Louis Chivacheff uses his artistic senses to provide a more interesting combination.

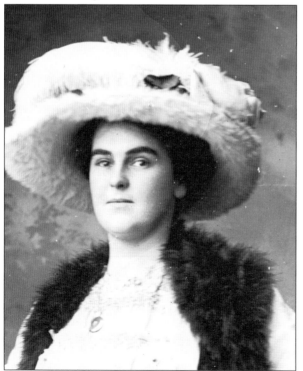

The large white hat appears to be made of goose down feathers. While Sears, Roebuck and Company offered $3 or $4 hats for the price of $2 in 1902, most of the hats seen here were likely purchased in New York City or Paris for a hefty price.

The simple broad-rimmed straw hat was more practical and less costly but could be decorated when occasions called for a more elegant look.

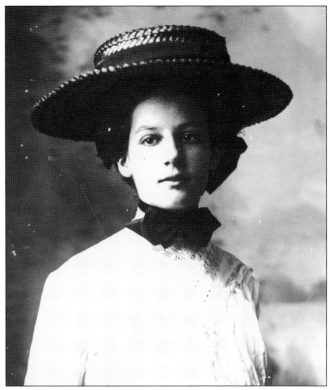

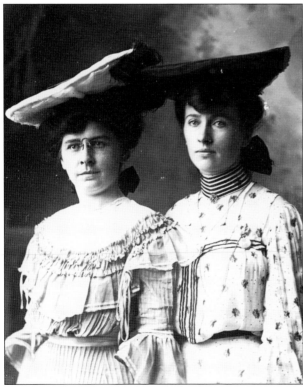

Two ladies show off their pancake hats. Note the spectacles on the lady to the left in the photograph. They have no temples or sidepieces but rest entirely on the nose. The other lady wears a locket or watch brooch and another pin at her high neck.

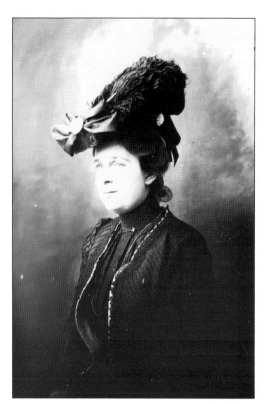

These are examples of hats of the early 1900s. Women of the 18th century wore mobcaps that protected their hair from dirt and smoke in an era when bathing was infrequent. Early-19th-century women wore broad-rimmed bonnets as they traveled west in covered wagons to settle in the new territories. Even the soft broad straw hats that protected women working in the fields all were hats with a purpose. These hats are purely fashion statements.

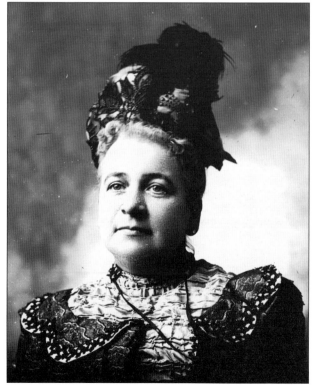

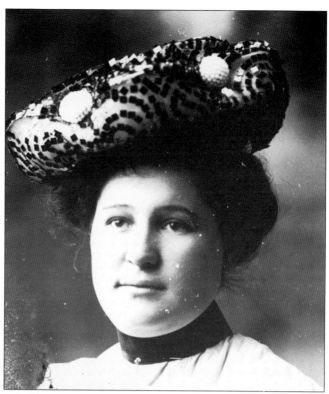

Hat varieties that women chose to wear are shown, and one wonders what happened to the practical head coverings. Women were not expected to further their education, could not yet vote or even talk politics, and were not considered intellectual, but they could certainly express themselves through fashions of the day. One could purchase a plain hat form and order flowers, ribbon, feathers, and other trims to compose an individual composition. More affluent women visited a milliner to design one-of-a-kind hats for them.

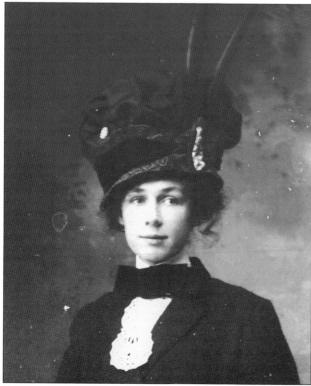

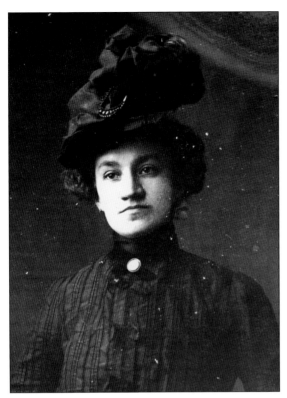

Ladies in these photographs wear clothing with expensive buttons and trimming to compliment their elaborate headwear. The women who posed for Louis Chivacheff in such fancy dress were probably the boarders or mountain residents who regularly sat for photographs to place in albums or on the mantels in their homes. They of course were the ones who kept him in a profitable business that allowed him to purchase more equipment to pursue his pastime of recording everyday life.

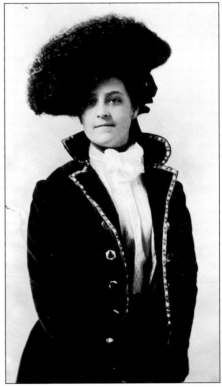

This stylish lady wears a top-heavy hat and a dress with at least 10 large-size buttons. Remember grandmother's button box that held replacements for buttons that were lost?

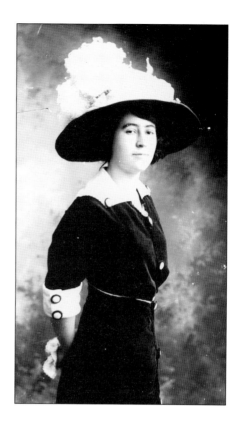

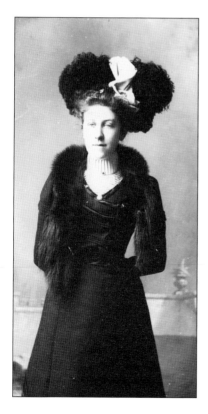

Fur pieces are now added to the realm of hats.

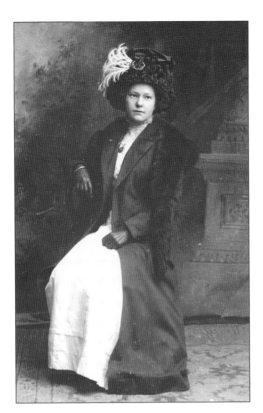

An ostrich plume hat with decorative bow and pins adorns the head of the lady seen here.

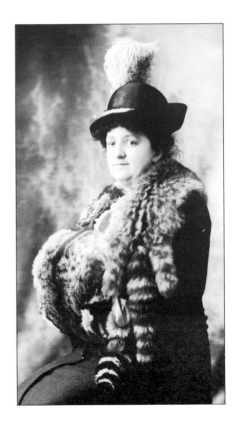

The lady here is adorned in raccoon tails and fur muff.

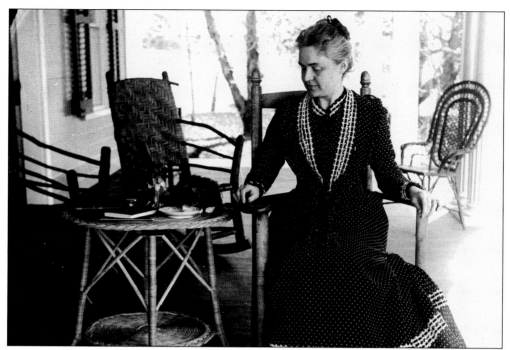

The photograph shows much. The lady wears a lovely dotted Swiss dress and sits on a porch furnished with Adirondack and wicker furniture, with a kitten lapping up milk from a saucer on the table. It is an example of a peaceful and contented household.

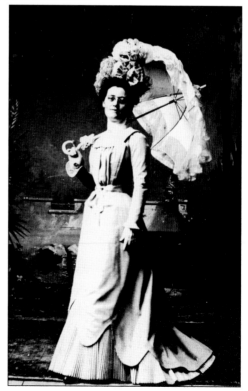

This elegant outfit from parasol, chapeau, and gloves down to the scalloped overskirt of the dress shows what the wealthy lady would wear.

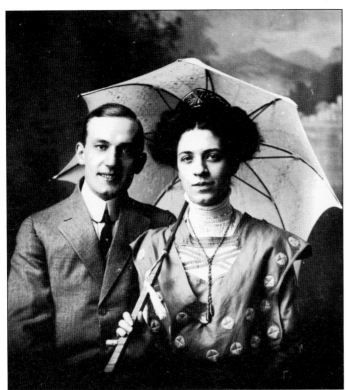

The couple in this photograph is a bit more informal, the parasol with a flat wooden handle, plain and simple.

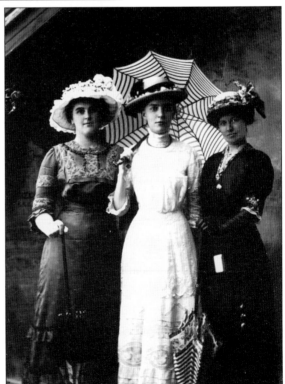

Three young ladies show off dresses, hats, and parasols. The studio lighting comes from the ceiling window in the upper left corner of the photograph.

Two young ladies dressed for graduation give examples of styles worn well into the 1920s. Some types of clothing remained quite appropriate for occasions such as this through several generations. A white dress is a white dress with maybe a sleeve or neckline change or a variety of trims.

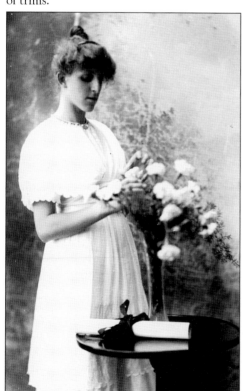

Babies held here in their mothers' arms seem oblivious to the outrageous headwear. A mother's voice and presence covers all fear.

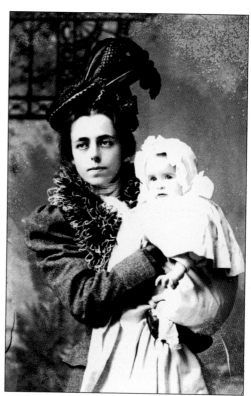

One fashion dictionary, in trying to describe the hats of the early 20th century, could only say that it was excessive.

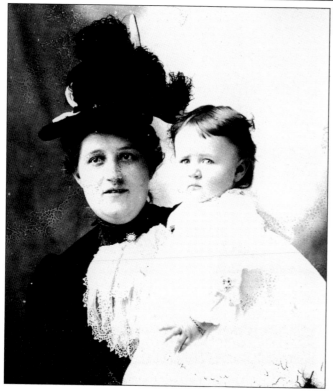

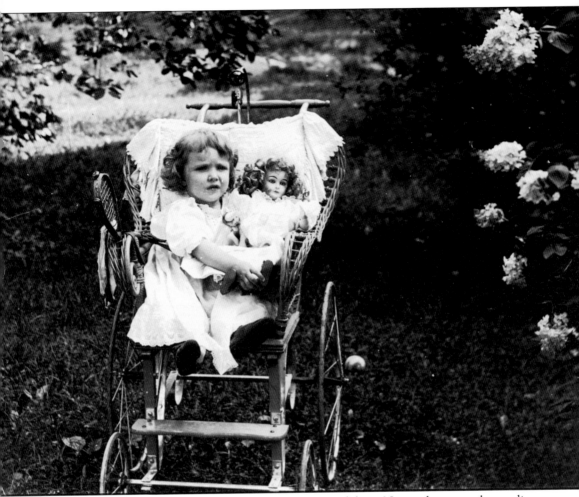

A young girl has a doll dressed to match her eyelet-trimmed dress. Notice the toy rattle standing in the left side of the stroller.

Three generations of men pose for the camera. Each one is dressed a bit more stylish than his elder.

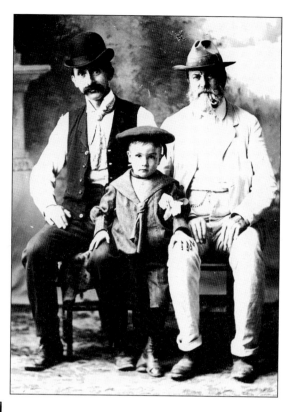

A casually dressed father probably cannot wait until his son is old enough to dress like a boy.

This handsome fellow is clad in matching pants and jacket and wears a pinky ring. He seems most pleased with himself in his attire.

Dressed up in a suit with a vest this fellow leans against a chair seen often in Louis Chivacheff's photographs. It is now the cherished possession of his grandnieces Doris and Jane Hennessey.

A matching pants and jacket are worn over a starched collar shirt and a tie with a stick pin. The vest holds a chain and charm.

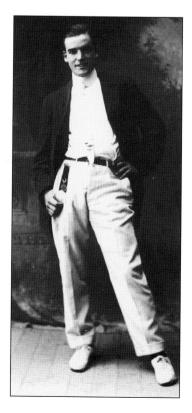

This fellow poses casually displaying a pocket charm.

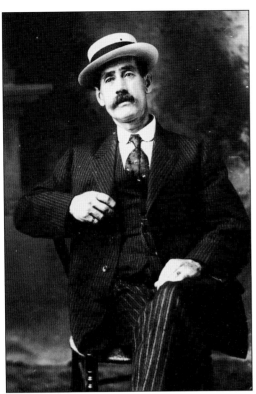

Pinstripes gained popularity. Add a fancy tie and a straw hat, and this mustached man is a picture.

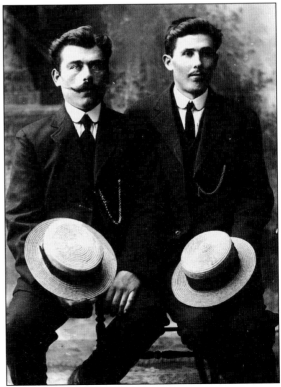

Two men pose with straw hats and watch chains. One sports a handlebar mustache.

The mustache worn by this young man needs more growth and trimming.

A man with graying hair shows off a neatly cared for beard and mustache.

A mustache worn by the younger man here imitates that of Theodore "Teddy" Roosevelt, who became a popular figure after his days as a Rough Rider.

The man pictured here with unevenly parted hair and a mustache sports a very large and fancy tie.

Special functions called for formal wear. Later semiformal wear called tuxedos were popular. They were designed without tails and had their origin in Tuxedo, New York, from a wealthy man, Pierre Lourillard, who resided there and dressed for European society.

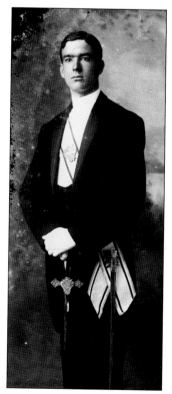

The handsome attire seen in this photograph is that of a member of Knights of Columbus, an organization within the Catholic Church.

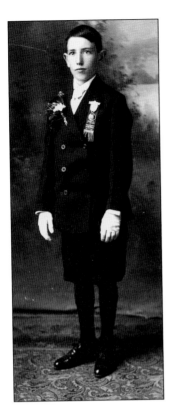

This young boy wears a medal ribbon that reads "St. Thomas of Canterbury Church, May 1900." Boys of this age had not yet graduated to long trousers.

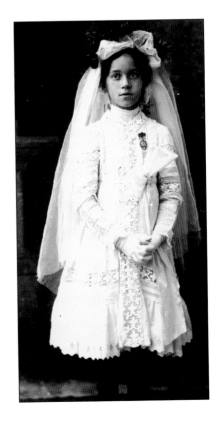

First Holy Communion day for this girl shows a dress with lace inserts, gloves, and a veil covered with flowers. The pin she is wearing became a special heirloom.

Eight

FOR LOVE OF COUNTRY

Many 18th-century inhabitants were eager to join the Committee of Safety when problems with England arose. Cornwall men marched off to the Civil War, a number of them with Col. Augustus van Horne Ellis's 124th "Orange Blossoms" Regiment that fought gallantly at Gettysburg and Devil's Den. Land donated by the Sands family, local Quakers, was given to erect a memorial for the soldiers at the end of the war. It was dedicated on July 4, 1904, with a number of Civil War veterans present. The GAR, an organization of men who saw battle, had a chapter in Cornwall that was named Emslie Post to honor William Emslie, who fought with the 2nd New York Cavalry and was captured. It was voted at the July 26, 1904, meeting that a request be made to Congressman Thomas Bradley, one of the speakers at dedication day, to acquire a Civil War cannon to be placed on the grounds and that "thanks be extended to Mr. Chivacheff for his kindness in presenting the Post with a fine picture of the Monument." World War I aroused the patriotism of local boys such as William Kane. The *Cornwall Local* reported on March 7, 1918, that "William Kane, sixteen, who disappeared last Thursday, has been discovered enlisted in the aviation corps. The lad left here after being discharged from the Firth Carpet Mill, where he has been employed. It is thought that an effort will be made to have him released from the army." He was sent home but wasted no time in trying again. He ended up with C Company of the 29th Engineers. He was wounded in France, received a Purple Heart, and once home and married, he named his daughter Patricia after the nurse who cared for him in the French hospital. She resides in the village today. The newspaper reported that Louis Chivacheff knit a scarf with his own hands for the Red Cross effort to be sent to overseas.

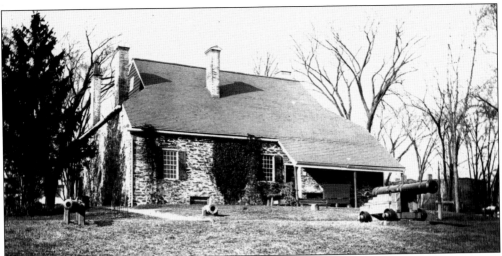

Washington's Headquarters in Newburgh was the first national historic site in America. George Washington spent more time here than in any other encampment of his military career, and Martha joined him. The house belonged to Jonathon Hasbrouck and commanded an important view of the Hudson River and any boat activity coming upriver.

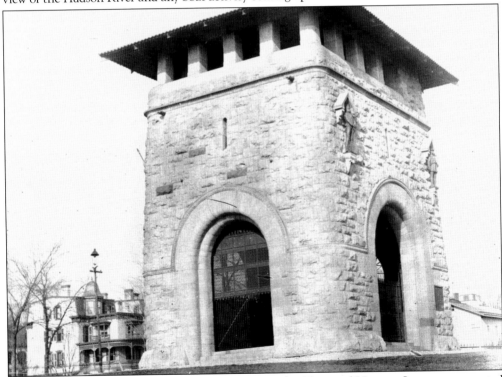

On the grounds of Washington's Headquarters is the Tower of Victory. It was constructed at the end of the 19th century and has the following inscribed on it: "This monument was erected under the authority of the Congress of the United States, and of the State of New York, in commemoration of the disbandment, under proclamation of the Continental Congress of October 18, 1783, of the armies by whose patriotic and military virtue our National Independence and sovereignty were established."

Knox's Headquarters in New Windsor was the home of the Ellison family. While Gen. Henry Knox was quartered there, it was the center of much social activity. Like Washington's Headquarters, it is a museum site today open to the public.

The dilapidated home, built by Jonas Williams, was the temporary quarters of Gen. Marquis de Lafayette on Forge Hill Road in New Windsor. This road was named for Samuel Brewster's forge, where chain fortifications were made that were placed in the Hudson River during the Revolutionary War.

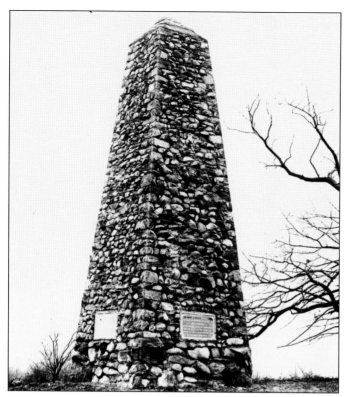

The Temple Hill Monument in New Windsor was erected to mark the spot where George Washington gave his famous address to his officers preventing their march on Congress to demand back pay. Rev. Elwood Corning was instrumental in forwarding the project, and the National Temple Hill Association, which he helped to form, is in existence today with an interest in preservation of early homes and history in New Windsor.

The Soldiers and Sailors Monument was dedicated in Cornwall on July 4, 1904. Perhaps this special celebration sparked Louis Chivacheff's interest in the early history of the surrounding communities previously mentioned. Catherine Wood donated the land soon after the Civil War so that a memorial might be constructed to remember those men who served. It is directly opposite the Sands Ring Homestead, the 18th-century home of Catherine Wood's Quaker ancestors, the Sands. Charles Curie, who fought at the Battle of Antietam with Hawkins Zouaves (the 9th New York Volunteers), was in charge of arranging for a monument. He had a marble shaft made in the Barre, Vermont, quarry, which is a replica of the one standing on the Antietam battleground but on a smaller scale.

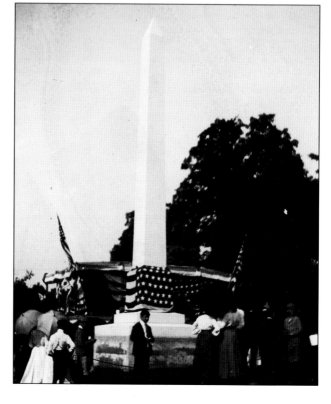

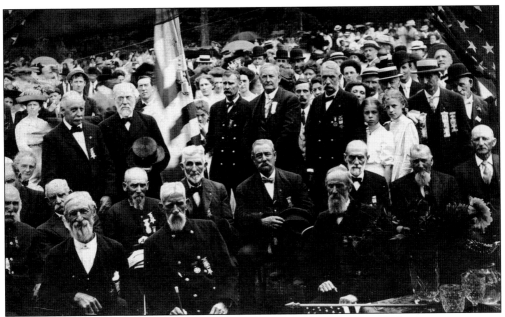

More than 2,500 citizens attended the dedication of the monument, the most important guests being the veterans of the Civil War. Some of them seen here are George Chatfield, John McClean, Charles Haggerty, Luke Lancaster, Frank Edwards, George Dubiski, Charles Edwards, George Walsh, Thomas Taft Sr., Fred Diesendorf, Eli McCreery, Edward Lamb, and R. S. Talbot. The two young girls are Margaret Tompkins and Ida Horobin.

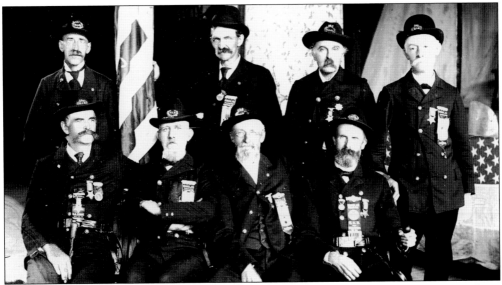

Members of the GAR were veterans of the Civil War who held regular meetings in the village. Each year, they voted to send representatives to the national encampments held throughout the United States where the men would reminisce about their war experiences. Here they pose in their uniforms with the GAR ribbons stating the name of Cornwall's post, Emslie, after their comrade who died in Andersonville prison after his capture during the war.

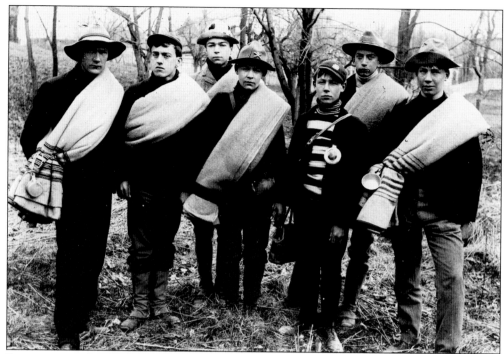

Boys preparing for a campout in the likeness of military men display some of the items necessary for camp. Teddy Roosevelt's Rough Riders were quickly idolized and imitated following the war in Cuba.

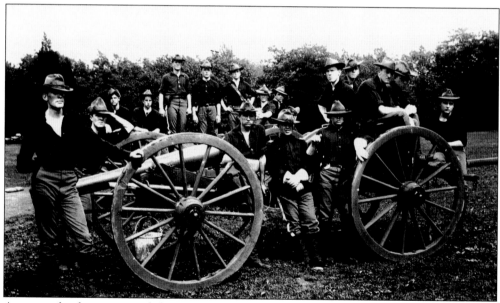

A group of cadets pose amid the cannons on the grounds of the New York Military Academy. Many of them would be destined to accept the next call to arms in foreign lands preserving their nation's freedom.

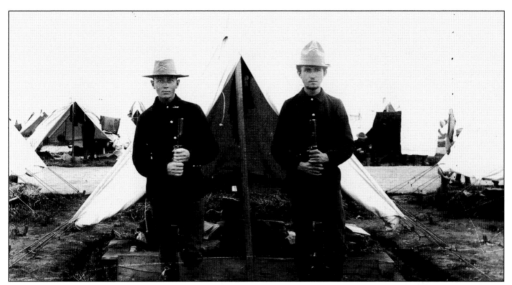

The camp setup of soldiers called into service demonstrates the barest of necessities. Capt. Winston Menjies, of the New York Military Academy class of 1893, was one who had served in the Spanish-American War. Clifton Beckwith Brown, class of 1896, lost his life while fighting gallantly on San Juan Hill.

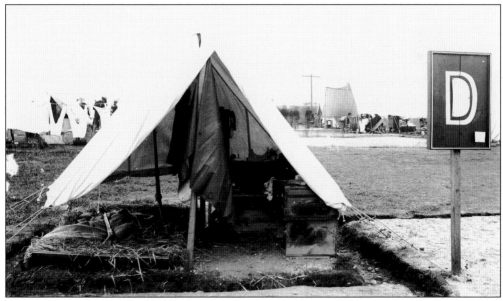

Another example of camp setup shows the trunk for important belongings, the bed made of straw, and the necessary rifle. Clothing is drying on the lines to the rear of the tents. The Cornwall Village Band voted to meet the Cornwall boys of Company D at the railroad station as they returned from the war in 1899.

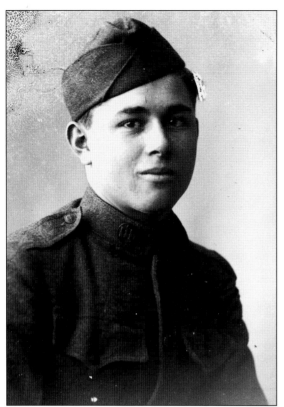

William Kane was too young to go to war, but he tried twice before receiving the blessings of his mother. Kane, one of 12 brothers and sisters, attended Cornwall-on-Hudson School and went to work with William Peck to learn the plumber's trade. Once in the army, he wrote home faithfully and described his trip to France: "The weather was fine and the sea was as calm as the good old Hudson." In another paragraph he says, "there are plenty of places to get liquor and vintages but I shall follow your advice and keep away from liquors of all kind." He ended up with a rifle bullet in his leg and was treated by a nurse named Patricia in the French hospital.

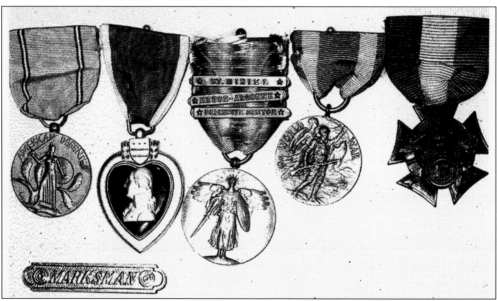

The medals Kane received are, from left to right, American Defense, World War I Purple Heart, World War I Victory with three battle bars, World War I Victory Medal issued by New York State, and the World War I Victory Medal issued by the City of Newburgh. His daughter, Patricia, lives in the village, and his son William lives nearby. This photograph is courtesy of Henry Costabel Jr., William Kane's grandnephew.

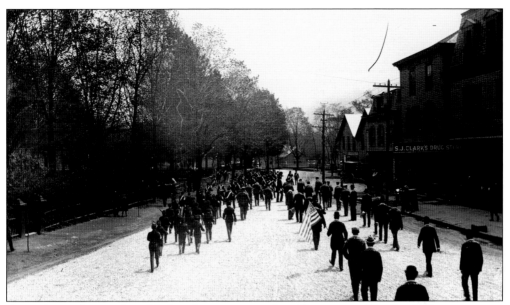

A parade marches south on Hudson Street just past the village square. The Smith House property (now the site of the Cornwall-on-Hudson Elementary School) is on the left with the majestic Storm King Mountain in the distance. Cornwall-on-Hudson needed little excuse to organize a parade. The annual Fourth of July parade has become a well-known and much-anticipated event. The Memorial Day parade planned each year by the American Legion is reminiscent of what was once called Decoration Day, when veterans marched to the graves to place fresh flowers there.

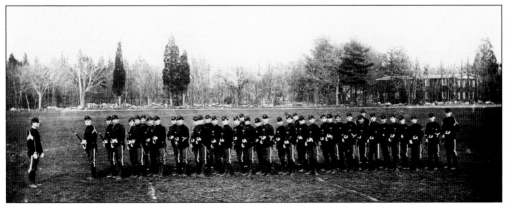

A dress parade at New York Military Academy grounds shows the Old Red Mill on the Idlewild Creek in the background. The foundation is all that is left of the mill that David Clark operated in the 1700s. The parade field is used to this day by the cadets who march in full dress uniform each week.

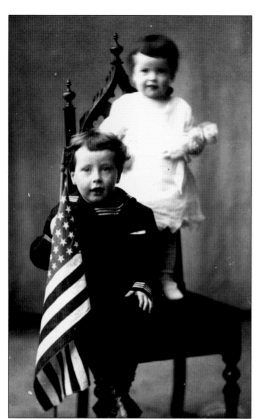

Every patriotic holiday brought out the American flag, and children loved to show their spirit. Louis Chivacheff took this image of Johnny O'Neil in his sailor suit with his sister Margaret. Sadly Johnny died in an automobile accident in his 20s.

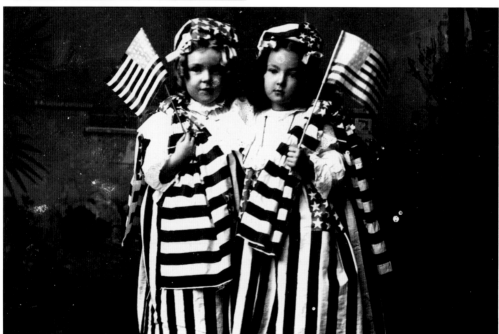

Flags were not enough for the girls seen in this photograph. They had dresses, bonnets, and shoulder pieces in red and white stripes, probably for a parade or patriotic play.

Nine

ON THE HUDSON RIVER

The Ward brothers became champions of the world at the International Regatta at Saratoga in 1871. They grew up, a family of 12 children, on the Hudson River where boating and fishing absorbed their lives. Several of the boys won races and trophies both as a team and in single competition. Some of the boys coached college teams. In later years, Gilbert taught a sculling crew at New York Military Academy briefly, taking them to a championship. Louis Chivacheff was also employed there for a while as an art instructor. Many of his photographs appear in their yearbook, the *Shrapnel*, including the one at Ward's Dock, with the boys carrying their sculls to the water. The Ontario and Western Railroad Coal Dock is seen in the background jutting far out into the river. It was an amazing operation where coal brought from Pennsylvania by train was loaded onto barges stationed below the train dock and then transported to New York City and Albany. When ice on the river became too thick, the business closed to reopen in the spring. Before the days of ice cutters, there were boats sent from Newburgh to Cornwall Bay to clear the ice for the "night" boats coming upriver. Occasionally there was a shipwreck, and everyone scrambled to the shore to claim an article as a souvenir.

Leonard Clark was another busy person on the Hudson River. He had a boatbuilding business and had small boats for hire. One Decoration Day, he had more than 70 boats rented to the public. In the winter, he built toboggans for the Cornwall Mountain House to use on its property and some were sent to Scandinavia. He built several homes on River Avenue, which are there today.

Pleasure boating was enjoyed by everyone. The sailboat *Alice* was photographed by Chivacheff many times. Was this a boat he owned and named after his wife, or just the fact that taking a picture on the water with the sun reflecting everywhere was not easy to accomplish with his equipment? The Cornwall Yacht Club occupies this area today and satisfies the needs of many boaters. Plans are in progress to improve launches for boats, canoes, and kayaks nearby. The heavily populated landing and railroad tracks of an early period are long gone, replaced with one track for freight and a lovely park for the enjoyment of residents and visitors to Cornwall-on-Hudson.

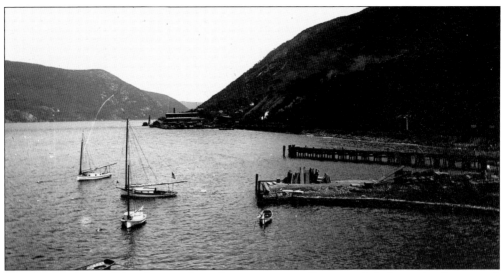

Here is busy Cornwall Landing, with rowboats, canoes, sailboats, and docks in the foreground, a steam train on the railroad tracks, and the Mead and Taft factory building in the background. The Storm King Mountain rises above on the right.

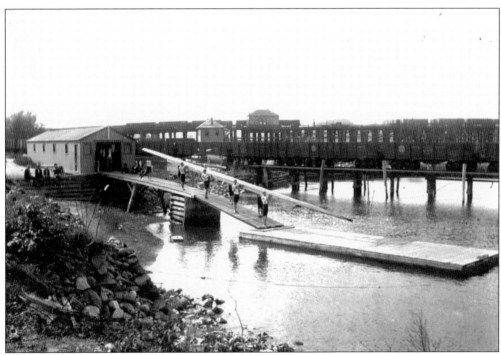

Ward's Beach, named after the famous oarsmen, is the site of the boathouse where several boys are carrying the sculls down the ramp to the Hudson River. The coal dock is seen in the background. It was a busy operation that employed many local people, some of them moving to the New Jersey office when ice on the river closed the enterprise for the season.

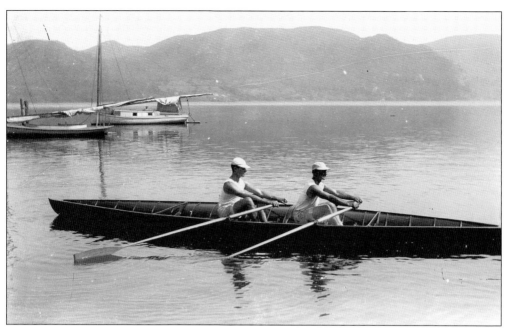

Gilbert Ward taught a crew at New York Military Academy for a couple of years and led them to a championship the second year he was their instructor. He and his brothers Joshua, Hank, and Ellis formed the team that won the race at Saratoga in 1871 that made them champions of the world, defeating teams from England and elsewhere. The brothers and their large family grew up in Cornwall-on-Hudson and won many individual races in their long career on the river.

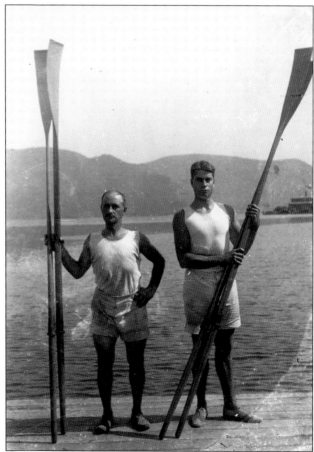

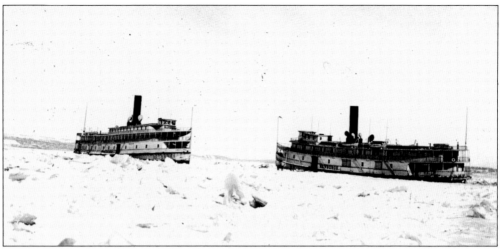

The *Homer Ramsdell* and *Newburgh* steamboats are stuck in the ice in Cornwall Bay. Before the days of Coast Guard ice cutters, these large boats were sometimes sent to clear the ice for the night boats coming upriver from New York City. This time was a disaster, and there are men standing out on the ice trying to envision a plan to help.

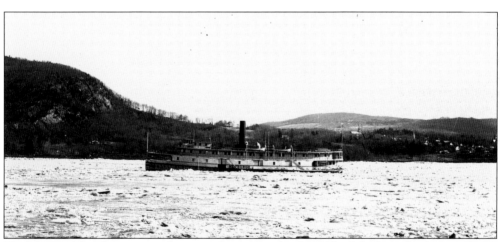

The *Newburgh* heads upriver in the ice in this image. April 1890 had the boats landing at Clark's Dock, while Salmon's Dock nearby was being repaired, likely because of damage done to the dock from the ice floes such as ones seen here.

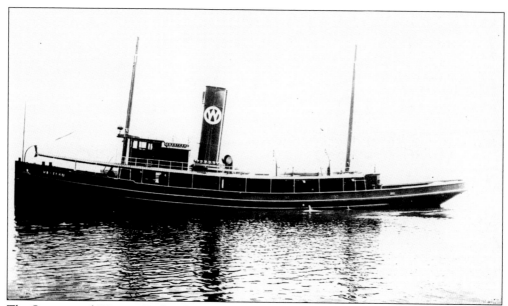

The Ontario and Western Railroad Company owned the coal dock operation that was completed in 1892. This is one of the tugboats that pulled the barges into place. The barges would be anchored beneath the coal cars of the train, and the coal was then released and filled the barges. The tugboat would then take the barges north to Albany or south to New York City where coal was needed.

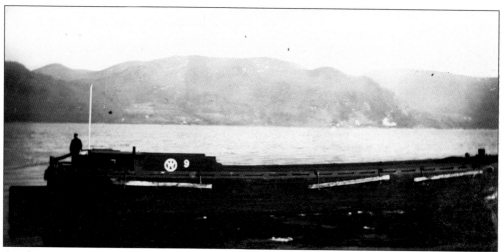

An Ontario and Western Railroad barge No. 9, pulled by the company's tugboat, received the coal released from the coal cars and transported it to other places.

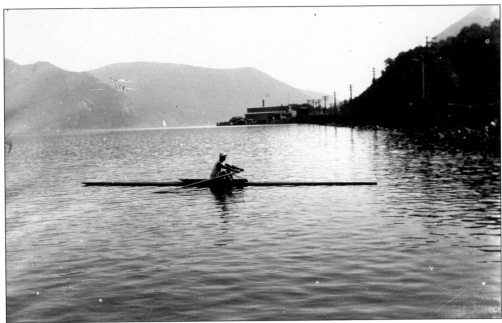

In this image, a lone scull heads back to shore in the evening after a day on the river. A single-crew scull such as this one was extremely long in length and the one that the Ward brothers competed in individually before forming a four-man team.

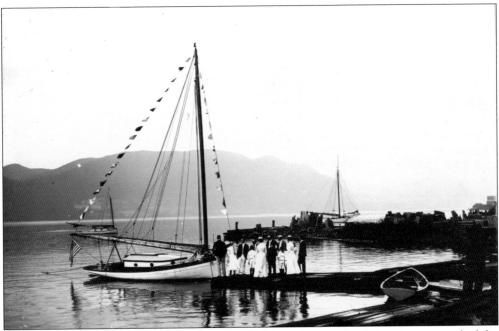

Louis Chivacheff took a large number of plates of the sailboat *Alice*. There is no record of the owner of this boat, but here a group of people prepares to enjoy an outing on the river.

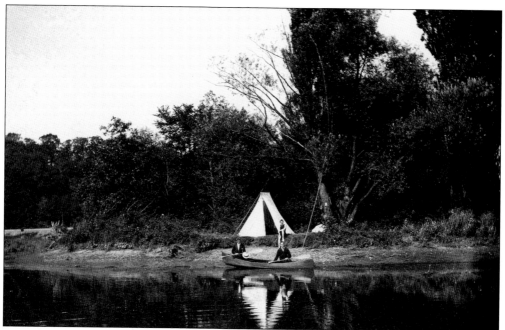

A small cove on the river near the sandbars was a favorite camping site for many residents. Swimming in the river was a summer enjoyment, and the water was not too deep in this location.

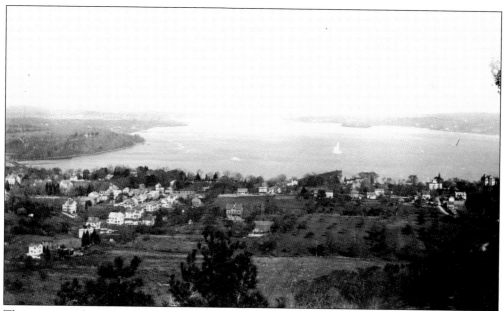

The view seen here shows the village of Cornwall-on-Hudson and many of the buildings yet in existence. It was taken from Storm King Mountain and shows the mighty Hudson River, the two attributes that make the village of Cornwall-on-Hudson the favorite place that it is. The images that Chivacheff chose to capture are an indication of the love he had for the place that became his lifetime home. He died in May 1940, and Alice outlived him by many years.

ACROSS AMERICA, PEOPLE ARE DISCOVERING SOMETHING WONDERFUL. THEIR HERITAGE.

Arcadia Publishing is the leading local history publisher in the United States. With more than 3,000 titles in print and hundreds of new titles released every year, Arcadia has extensive specialized experience chronicling the history of communities and celebrating America's hidden stories, bringing to life the people, places, and events from the past. To discover the history of other communities across the nation, please visit:

www.arcadiapublishing.com

Customized search tools allow you to find regional history books about the town where you grew up, the cities where your friends and family live, the town where your parents met, or even that retirement spot you've been dreaming about.